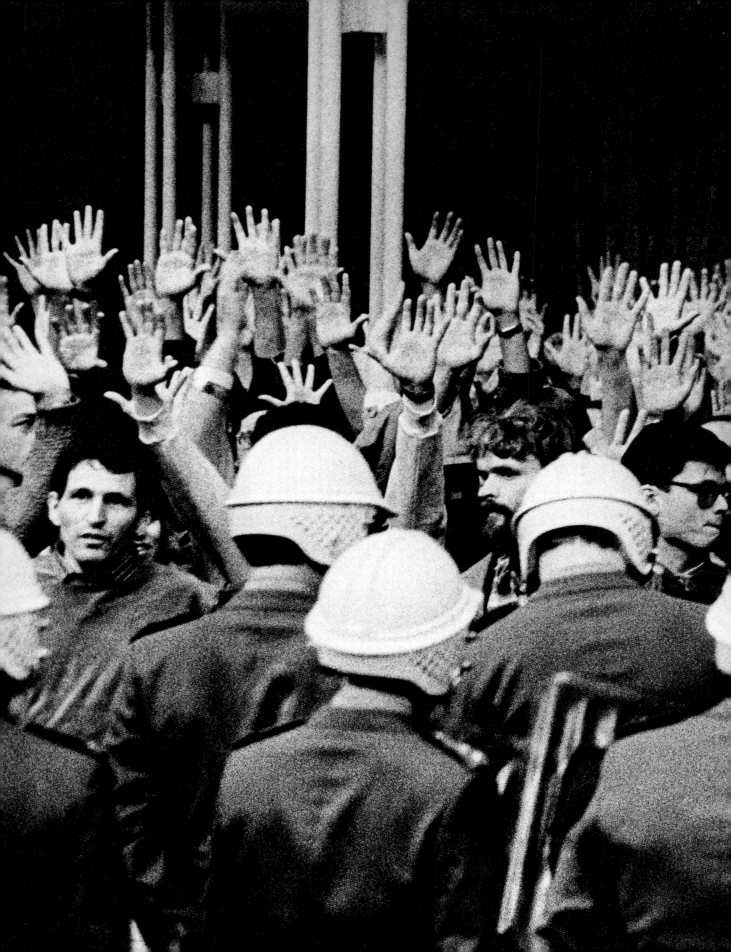

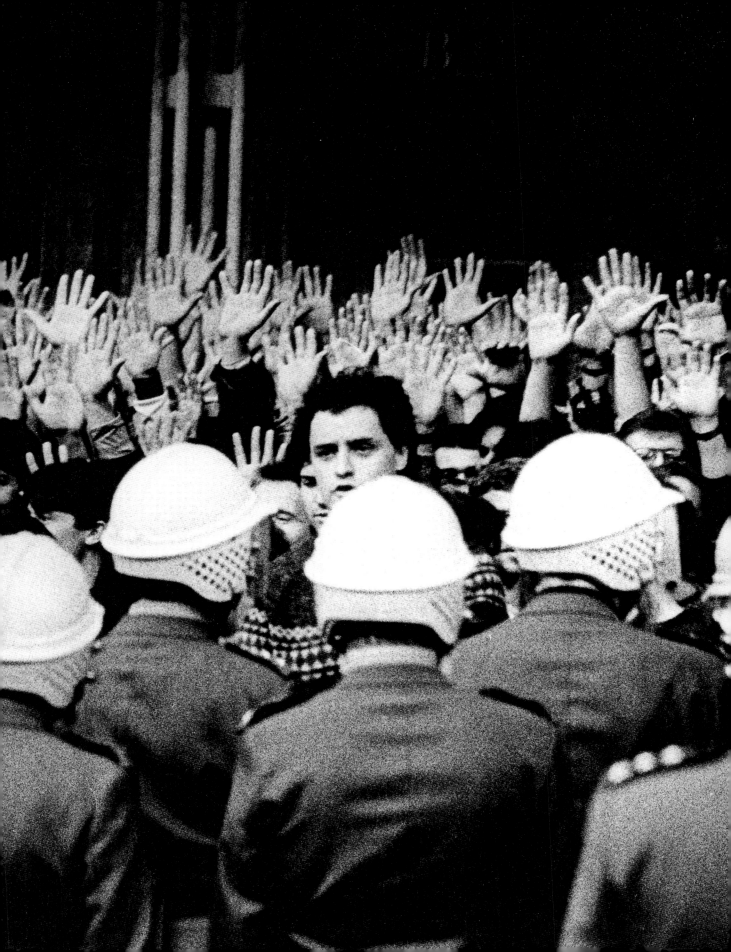

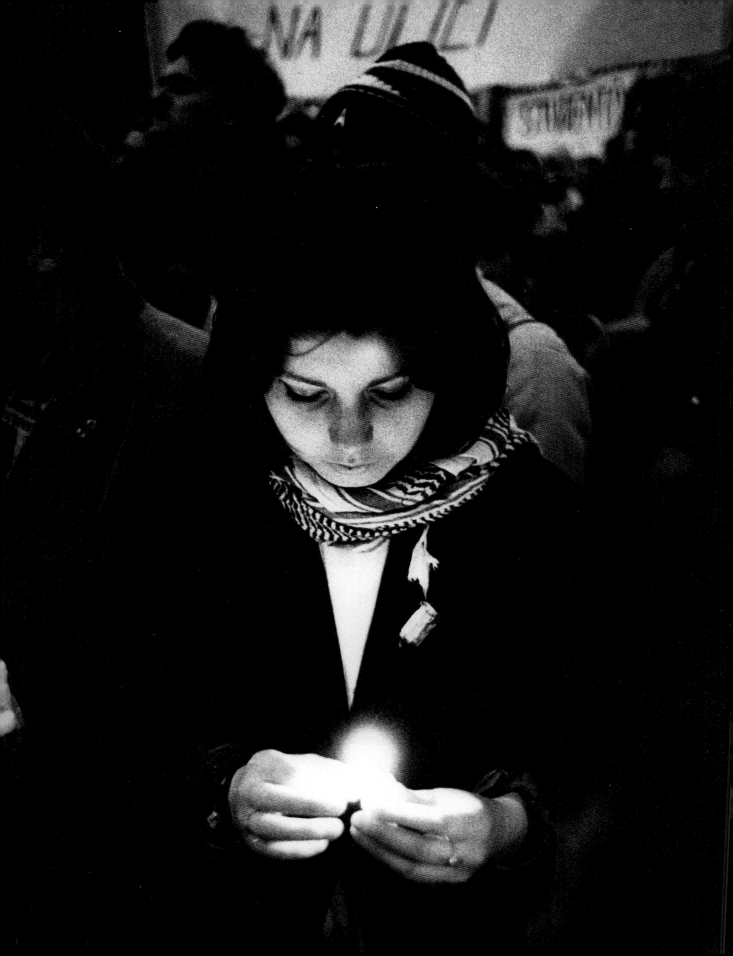

Daniel Kroupa
Monika MacDonagh-Pajerová
Jolyon Naegele
Jan Sokol
Olga Sommerová

The Velvet Revolution
30 Years After

CHARLES UNIVERSITY
KAROLINUM PRESS 2019

KAROLINUM PRESS is a publishing department of Charles University
Ovocný trh 560/5, 116 36 Prague 1, Czech Republic
www.karolinum.cz

Simultaneously published in Czech as *Sametová revoluce 30 let poté*,
Prague: Karolinum, 2019

ISBN 978-80-246-4448-6

CONTENTS

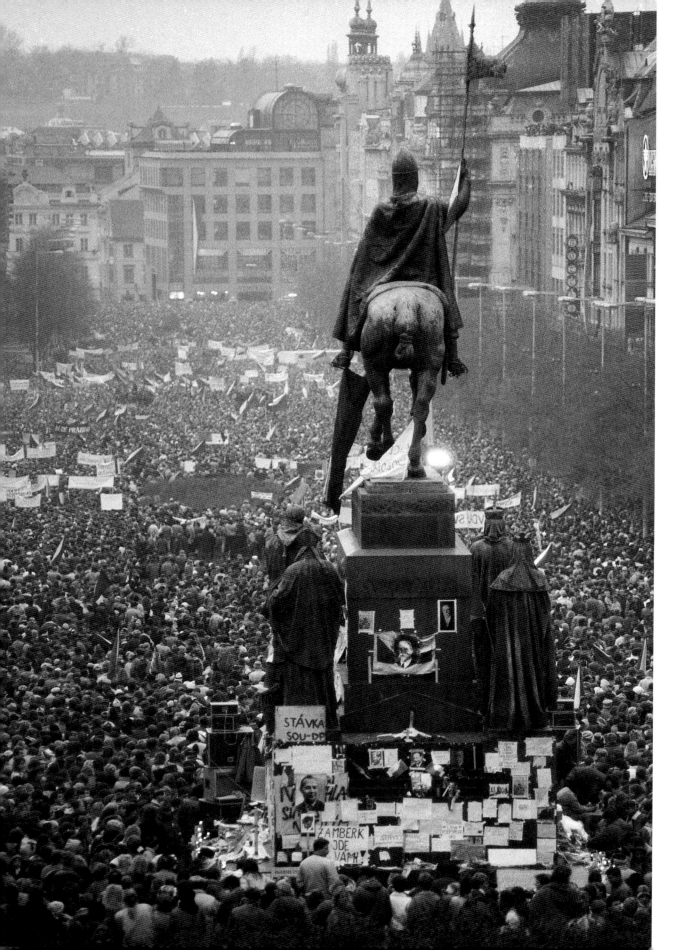

PREFACE

My life has been divided between totalitarianism and democracy. I lived for 40 years under the communist regime, and then for 30 years I have lived in democracy. As a teenager I experienced the exhilarating illusion of freedom at the end of the 1960s. The invasion of Russian tanks in August 1968 was a cruel awakening. This has remained a quite fundamental experience in my life, which definitively confirmed my conviction that the only path in life is the defence of truth against lies.

Inspired by Buddhist monks, for whom self-immolation is a radical form of political protest, on 16th January 1969 on Wenceslas Square student Jan Palach became a flaming torch, which constituted a scream against the creeping moral corruption of the nation as a result of the brutal Russian occupation in 1968. For those who were witnesses of his absolute sacrifice Jan became a rousing memento: we can never again sign a contract with the devil; it is not possible to live in lies and without freedom!

During the following 20 years of so-called normalization the devil of communism was a mendacious, besmirched demon which destroyed the lives of hundreds of thousands of people, which robbed people of hope for a dignified private and public life. This devil threw those who refused to abase themselves out of their jobs, bullied and intimidated them, beat them and shut them up in prison; it drove out of the country men and women who belonged to the elite of the Czech nation, and this happened for the second time in the 20th century. It broke the moral backbone of a majority of citizens, who in an effort to defend the existence of their families did not speak in the same way that they thought. The devil of communism stamped on their identity.

At the beginning of the new millennium I started to film the documentary cycle *The Lost Soul of the Nation* about people who stood up to the criminal communist regime. They lost their freedom, their wives, husbands, their civic life, and they were imprisoned, tortured and humiliated in communist prison camps. The 16 heroes of my film were a small fragment of the victims of the inhumane regime. We should never forget these numbers! This regime, whose successors and ideological adherents are represented in the parliament of a democratic republic, illegally convicted more than 205,000 innocent people, and it executed 248 human souls. At the borders it shot dead 145 people who were determined to leave, and it left over 4,500 prisoners to die in prisons and labour camps. In addition to these numbers, there can be added the many many more cases of destroyed lives of their family members, relatives and friends, widows and widowers, abandoned children and orphans.

I returned to the theme of communism with my film *Without Punishment, Without Repentance*. Prisoners from the 1950s, who have not even been acknowledged with the status of the third resistance even though they stood up to a regime that was even more dreadful than Nazism, expressed their opinion about the concept of a 'thick line', which was established in our society in the conciliatory and joyful post-revolutionary atmosphere. Today I now know that joy and reconciliation were not the real reason for the euphemism 'thick line'. It is not possible to draw a thick line under marred and lost lives. The only possibility is the path from repentance to punishment and consequent forgiveness.

← View of Wenceslas Square in Prague during one of the demonstrations in November 1989 (ČTK)

A decisive experience in both my personal and professional life was the making of a triptych of films about the 21 spokespersons of Charter 77, who engaged in active civic resistance against communist power and defended civil rights for a period of 13 years. While filming with the heroes of this film I found myself in a world in which people do not modify their opinions with a view to their own personal gain, in a world of thought in which respect for truth persists and in which every person retained the integrity of their own personality by standing up against the powerful even at the risk of losing their employment and their comfortable lives and at the risk of intimidation and imprisonment. Charter 77 was the first significant representative of civil society here in the Czech Republic, and its message that in no circumstances should people give up responsibility for public affairs, remains relevant today.

On Friday 17th November we filmed the enthralling student demonstration, which was ended by a brutal police intervention on National Boulevard (Národní třída). In modern Czech history it has been primarily students who have initiated social changes. In 1989 it was students who initiated the Velvet Revolution, which became the trigger for a political revolution, for a transformation of the 40-year-long totalitarian regime into a democracy. The greatest wish of the student elite at that time was a desire for freedom and democracy. This desire was fulfilled. My greatest wish in life – that the Communists fall through the trapdoor of history, never to be seen again – was not fulfilled. For a few years after the revolution we were enthralled and joyful, and we did not devote sufficient attention to the fact that the Communist Party – making its way toward the scrapheap of history – had entered the palace in which the Parliament of the Czech Republic is seated.

During the 100 years of the republic's existence for one half of this time we have been occupied, primarily by a criminal communist power. Both totalitarian regimes, Nazi and communist, committed damage to the soul and morality of the nation that we have still not come to terms with. The consequences of this damage are apparent in the current adverse political situation. The ethos and principles of democracy have failed to take root in the citizens of our republic. The 20 years of the democratic First Republic (1918-38) were interrupted by the Nazi occupation, which was quickly followed by the communist totalitarian regime.

After 30 years of democratic renewal, now the nation, which has lost its memory, is not doing well. The crimes of high-ranking communist functionaries and of members of the State Security apparatus have not even been designated and named, let alone punished. We have forgotten to systematically defend and cultivate democracy. And that is why the posthumous advocates of totalitarian ideology are now crawling out of their holes, occupying powerful posts, creeping into the state administration and laughing in the faces of democracy and citizens.

In 2019 hope can be taken from the democratic-thinking citizens of the student initiative A Million Moments for Democracy, which has awakened civil society to protests against the country's current political rulers, who are stamping democracy under their feet. This initiative continues a tradition of Czech student revolts in 1939, 1948, 1968 and 1989.

This is why this book contains interviews with Monika MacDonagh-Pajerová, one of the student leaders in 1989, as well as with Jan Sokol and Daniela Kroupa, two philosophers who were signatories of Charter 77 and are representatives of the resistance to the totalitarian manipulation of Czech society. I hope that Czech society bears in its social consciousness the democratic legacy of Tomáš Garrigue Masaryk, the founding president of the Czechoslovak Republic who chose the motto Truth Will Prevail for the presidential emblem.

Olga Sommerová

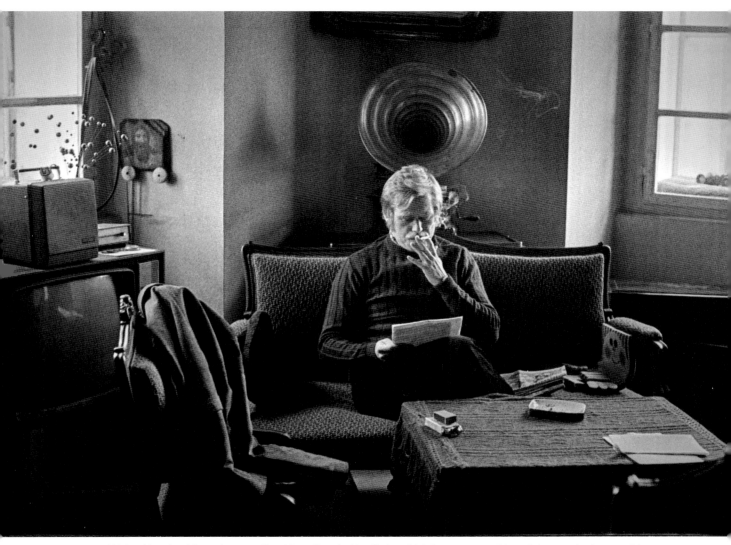

Václav Havel writing a letter to President Gustáv Husák, in which he expresses his opinion on the lamentable state of Czechoslovak society – before the foundation of Charter 77. (Oldřich Škácha)

JAN SOKOL

Can we talk about some kind of permanent legacy of the democratic First Czechoslovak Republic (1918–38) for the current day?

One of these historical experiences is the end of democracy, and in fact even of the state itself, after the Munich Agreement. We must not forget how we are dependent on the international environment, and so European integration is vitally important for our nation. When the Eurosceptics try to persuade us that we will be 'dissolved' in Europe, that we will lose out in this process, this is very stupid indeed and it is not even true. From the point of view of peace in Europe and our freedom the EU is an essential thing, and it makes me sad that our politicians devote so little attention to this.

Czech ruling politicians are incomprehensibly inactive with respect to Brussels.

The strategy of some kind of a strange opposition/non-opposition toward the EU, which both of our last two presidents, Klaus and Zeman, have adopted, has immensely damaged us. Instead of us having the possibility of using our membership well, we are behaving like uncivilized bumpkins and shifting back to the East, from where we can expect nothing good. The Czech Republic must of course know how to promote its own interests through negotiation, and for a state of our size this means seeking allies in Europe, which cannot be only Hungary and Poland. Small countries, such as Holland, Denmark and Ireland, have similar interests to us, as also do our Western neighbours, Germany and Austria. We should cooperate with them, and by doing so influence decision-making at the European level. It definitely cannot be that we play at being some-kind of modern-day Jánošíks [Juraj Jánošík was a semi-legendary Slovak brigand promoted by the communists as an anti-feudal national hero who fought against the rich] and say no to everything. Those politicians who bear government responsibility know very well that this is just not possible, but the last two presidents have interpreted the constitution as saying that they are not responsible, and so they have behaved irresponsibly.

It is said that the Czechs are the most atheistic nation in Europe. Is this true? And, if so, what are the historic roots of this?

This is not an old matter. One hundred and twenty years ago, or one hundred and fifty, the Czech Lands were pious lands – absolutely and without reservation. The ceremonial laying of the foundation stone of the new Czech National Theatre had to be held on the day of Saint John of Nepomuk, a typical baroque saint, promoted by the Jesuits, because this was the day on which the greatest number of Czechs were in Prague. So, this move away from religion only started at the end of the 19th century, when the Catholic Church declined to become harnessed to the National Revival movement. One example: the Prague archbishop resisted the Theological Faculty being divided into a German faculty and a Czech faculty, because he said that a priest

in the Czech Lands must know both Czech and also German. This stance made the church less popular.

It was rather antiquated and conservative, but I think that the main reason for this alienation was precisely the fact that the Church did not resonate with this charged national spirit. And meanwhile in practice it was priests who bore the burden of the entire National Revival.

And not writers?

There were a few of those. But priests were educated people and there were thousands of them, and this is something entirely different from those few intellectuals who wrote books and founded museums and magazines. However, the Catholic Church was not very positively inclined toward democracies; it constantly looked back to a monarchical system, which seemed natural to it. The Catholic Church was not modern, it was loyal to the Austrian monarchy and it underestimated the significance of the national effort. On the other hand, thanks to this, the Czech church was never nationalist, in contrast to the Polish church or the Irish church. And then of course the years of communism also left their mark on the move away from faith.

But there was communism in Poland as well.

But there was an entirely different situation there. In Poland it was precisely the church that was the bearer of the national idea. The Russian occupation in Poland was much harsher than the Austrian rule, and so during a certain period it was forbidden to speak Polish at school. Polish was tolerated only at home and in church, and the church was a natural place for a nation to meet. For a Pole the words national and Catholic are one and the same. Just as they are in Ireland, and also to a certain extent in Hungary.

Here in the Czech Lands there was also a discord between Protestants and Catholics. In the 18th century the Czech Lands were almost completely Catholic. And moreover, very actively so. When Emperor Josef II issued the toleration patent in 1781, this meant that Protestants could also be buried in Catholic cemeteries, that these cemeteries ceased to belong to one particular confession. In several places around the Czech Lands the peasants resisted non-Catholics being buried there. Czech Catholicism of the Baroque era was bound to the countryside, to the landscape. When you travel around the Czech Lands, you will see everywhere how this landscape is formed by small churches, bell-towers and wayside shrines. Elsewhere Christianity is not connected so strongly with the landscape. However, then came urbanization, and as soon as people moved away to towns and cities, the common faith ceased to operate, because the church was founded on local communities. And when young people went away to cities, the church did not take much care of them there, and they really became alienated from the church. When Masaryk, then a liberal socialist, came to Prague, he complained in a letter about how strongly secularized the Czech Lands were, already back then. However, by this he meant mainly Prague.

Do you think that atheism or secularization have an influence on the spirit of the nation, on its citizens?

I think it does, but I would not say atheism. This is rather a case of a sort of private property in religion. My colleague Tomáš Halík, the theologian, calls this 'something-ism'. Each of us has some kind of his own rather fuzzy religious system, into which we do not allow anyone else.

Yes, Halík says that Czechs do not believe in God, but they say: 'I believe that there is something above me'.

I will in some way deal myself with what is above me and I am not going to talk with anyone else about this. This approach very much weakens the social side of Christianity, especially that in Catholicism. However, these 'believers in something' do not have anyone to rely on, anyone to turn to for support, and this is possibly the source of that Czech – to put it euphemistically – flexibility: such people are very adaptable.

To what?

To anything that is wanted from them at any given time. In the course of the 20th century the Czechs have had to reorient themselves several times. When Masaryk started in 1915 with the idea of an independent republic, this was not very popular with the general public. The university Senate stripped Masaryk of his professorship, and it did not have to do so. However, after 1918 our predecessors quickly adapted and became avid patriots. When the Germans came, some people once again adapted. The way in which the Czech authorities during the period of the Second Republic (1938–1939) accepted Hitler's anti-Semitism, this did not just happen of its own accord. I am not saying that this happened only in the Czech Lands, but it was pretty significant here.

I have a friend. He is a 94-year-old Jew, who survived Auschwitz, and he once told me that the Czechs are the least anti-Semitic nation in Europe.

Possibly the fact that we live in a big city may mislead you. Berlin is also not anti-Semitic. However, it is true that the attempts by right-wing extremist parties to make political capital out of racism have failed at least for the meantime. Their demonstrations, even during this extremely charged campaign against immigrants, have attracted only hundreds of people, not tens of thousands.

Consider how anti-Semitic the Poles or the Russians are. This is not an issue here in the Czech Republic. Possibly this is also that contribution of the democratic First Republic, which approached minorities on the basis of a civic principle.

Here the Jews assimilated soon and in large numbers. One Jewish woman we know recounted how she and her mother met President Masaryk, while they were walking across Wenceslas Square during the foundation of Czechoslovakia in 1918. And this five-year-old girl says: 'Mummy, look, a Galician Jew!' Because these bearded Galician Jews, who were coming here at that time, were conspicuously different. Havlíček [Karel Havlíček Borovský (1821-56) – Czech journalist and politician, leading figure in the National Revival] still regarded Jews as foreigners, but by the end of the century society in the towns was very individualized and secularized. There was no ideological monolith which would have excluded all others. And thanks to this, Jews could be closer to Czechs than – as far as I can judge – to Poles, for instance.

When you consider that during the 100 years of Czechoslovakia's existence we have been occupied for half of that, then it is fifty:fifty. This is not usual in the countries to the west of us.

That is true. They have been very lucky. But the French or the Dutch have also experienced occupation.

But this must have left a mark on our nation.

This is also a possible source of that Czech flexibility, a strategy for surviving in some way. People have learned how to weave and dodge their way through socially unfavourable situations in some way. Nevertheless, I would not like to condemn this capability to navigate one's way through in some fashion. Czechs submitted to the Nazis, but they did not become Nazis. Attempts at making Czechs into Nazis failed. There were French, Dutch, Estonian, Ukrainian and Norwegian SS units, made up of local volunteers, local Nazis. No such thing happened here, and they did not even try to do this. Apparently Hitler said that he needed Czechs to work for him, but that he did not want a bunch of Schweiks in the army. [Jaroslav Hašek's novel *The Good Soldier Švejk* describes the adventures of Private *Švejk* (Schweik), a Czech conscript to the Austrian army who uses all means possible to avoid having to fight for the monarchy]

Reinhard Heydrich [acting head of the Nazi Protectorate of Bohemia and Moravia from 1941 until his assassination in 1942] apparently said that Czechs are smiling devils. Let us move on to the communist terror: 248 people were executed; over 4,500 people died in prisons and camps; 145 were shot dead at the borders; over 205,000 people were unjustly prosecuted, found guilty and imprisoned; tens of thousands of families had their lives wrecked. The losses cannot be reckoned in numbers; 40 years is too long a time.

This is really a long time. In 1948 no-one believed that it was going to last so long. Many people believed that before the next plum harvest, in a year or two, it would fall apart. However, then the communists gradually shut these opponents up in camps and prisons. Yes, certainly it was a terrible regime, mainly in its early years. Nevertheless, even this terrible regime has some things to its account that we should also not forget. It was the communists who introduced some sensible social measures here, for instance universal health and pension insurance. This is no small thing. And, in spite of all the repellent ideology, education was also not so bad.

You have just spoken about a few positive acts of the communist regime. But in general this process of disintegration was fatal, and not only in irreversible material damage to a once rich country, but it was also fatal for the soul of the nation, for its morality. People noticed that the political trials of the 1950s were a fraud and a lie, and they had to live in this lie, unless they were in the resistance. This must have had an effect on the character of the nation. This inheritance persists up to this day.

The 1950s were cruel here in Czechoslovakia: fear, bullying, isolation. And this was the case even for people who were 'free', let alone for the people confined in the Jáchymov uranium mines or in the Bytíz prison camp. However, on the other hand, this cannot be compared with what happened in Russia or in Ukraine. Here in Czechoslovakia hundreds of people were executed; in Russia it was millions. We had no famine here. Nevertheless, we were all affected by the fact that the communists talked about socialism, but in practice they fragmented and atomized society – they taught us not to trust anyone.

Why did the Bolsheviks proceed so toughly against the Catholic Church?

Precisely because it was not flexible. Its head was in the Vatican, and the Bolsheviks did not have control of that.

During these sad years Christianity and Catholicism were a great support for us by enabling a person to say 'No', at least in some things. And in the later years the communists also perceived

it exactly in this way: they did not try very hard to persuade us to join the Communist Youth organization, or the party itself; we were restricted a little bit more than other people, but in their clumsy way they acknowledged us to a certain extent. And that is why I say that I did not fight against communism, but that the communists fought against us.

Milada Horáková [a liberal socialist politician] was the only woman to be executed during the communist regime. Under the Nazi regime she was imprisoned, condemned to death, but the sentence was not carried out. This was only actually done by the communists.

At the time petitions were circulating, signed by thousands of people, which approved the death sentence for Milada Horáková. The communists were successful in manipulating the masses and pretending that everyone agreed with this. In Russia they knew how to incite people against alleged enemies and traitors, and the communists here also learned how to do this. When a few of us in the workshop refused to sign the so-called Stockholm Appeal in 1953, the others tried to persuade us that it made no sense to refuse, and the director said that it would cause him problems.

Horáková was a heroine who, even though she knew that this would cost her her life, did not submit. And moreover a woman. This has a great significance for the soul of the nation.

This is a very important experience of the 20th century. For every nation, which finds itself in an unjust regime, it is important that there are at least a few people who have the courage to stand up against it. There are a few of these people, and thank God for them. In Germany under Hitler this was really only a handful, and today the Scholl siblings have a street named after them in every second town. Here we had Mrs. Horáková or later Václav Havel, who reminded us that this flexibility had gone too far. Milada Horáková was a woman of stature, and her tale is a part of the liquidation of the elite. The whole of Eastern Europe has suffered long term from the fact that capable and courageous people are periodically driven out or killed. All of the people driven out in these waves of emigration were competent, self-confident and energetic – and so only people like us are left.

How did you experience the Prague Spring and the consequent Russian occupation in August 1968?

We lived the 1960s with a sense of hope. On the one hand, certainly because we were young, but also because it seemed that the totalitarian regime could change a little. Small step by small step, but nevertheless. Friends came back from prison, and the communists looked around for people who would be willing to talk with them. From the start of the 1960s I had started to translate, first of all for friends as samizdat – and all of a sudden it was also possible to publish these things. In 1968 I was not capable of imagining that the Russians would dare to intervene militarily.

But they did dare to.

During those few months of more or less freedom two generations had a chance to try out what freedom felt like and that it was possible. This was an enormous difference compared to Russia. When I later travelled there in the 1970s, on the streets and in the pubs I was often told: You Czechs must be mad. Do you really think that people can live without fear? There must be a lash held above people; otherwise they will devour one another.

But in Czechoslovakia at that time people had experienced that people did not devour one another, that society could be free and that this did not mean that everyone had to fear everyone

else. The propaganda of dictators is always such as this: Be glad that there is a lash held above you, that your leader is protecting you. However, in the 1960s many Czechs visited the West and ascertained with consternation how different it was from back home. This also then played a large role in 1989.

That tremor of hope and freedom in 1968 was a really powerful experience for me. All of a sudden people were nice to one another, greeted one another, helped one another. The same thing happened during the revolution in 1989. People were in a good mood and they had great expectations.

For those few months of hope people reacted to the Soviet invasion like citizens of a free country. They understood that this was going to be a tough time and that they must act themselves. Even when no-one ordered them to do so, they organized self-made broadcasting and film reporting, they started to write messages on walls, to engage in discussion with the occupying soldiers – in short, to act like adult people. And all of a sudden even that communist state was not merely an enemy.

During the August invasion 137 civilians died. And during the course of the entire period of the presence of Soviet troops in Czechoslovakia 400 citizens were killed.

The August invasion differed from the occupation of Hungary in 1956 in that people all over the world could follow it on live TV. The fraud of the Soviet communist movement was revealed to the whole world. It discredited itself, and this was the start of its downfall. Even Western communists were overcome by a feeling of solidarity. Mainly in France and Italy this feeling also applied to their communist parties, and this was the start of the decline of these parties.

Did your family consider emigration?

Of course. At Siemens, for whom we (the Institute) did computer programming, I would have got a good job. However, both of us had elderly parents. We had three children, who were starting school, and in the end we said: let them go, not us; after all we belong here.

Signature of philosopher Jan Patočka confirming his agreement with the declaration of Charter 77

Jan Patočka (Oldřich Škácha)

And the knowledge that, if you left, you could never return, you would never see Prague and your friends, you would never return to your native land?

Yes, that played a role. Ten years later, when well-known dissident Svatopluk Karásek left for Switzerland and we went to say goodbye to him, many people were close to crying, as if he was going to Kamchatka or flying to the moon.

Why did you sign Charter 77?

Primarily this was no big dilemma for me. My father-in-law Jan Patočka was one of the three first spokespersons, along with Václav Havel and Jiří Hájek, the former foreign minister, who in 1968 protested at the UN against the Russian invasion. And in practice I was the only one in our family who could support him. Nevertheless, I never regretted signing it. When the Charter got into the Czechoslovak newspapers in January, I went to see the director of the institute I was working for and I said to him: Look, I signed the Charter. First of all, he almost had a heart attack, but then he brewed up a coffee, we sat down in the kitchen and we thought about how he would punish me.

And how did he punish you?

He reduced my salary, demoted me from my managerial post and expelled me from the trade union.

I then asked my colleagues to vote in favour of expelling me, to avoid causing too much trouble. In the computer programming section of the Institute (Research Institute of Mathematical Machines) there were six Chartists and I did not want any of them to be thrown out.

How were your children affected?

Our oldest daughter Mařenka would like to have studied languages, but it was clear that that was not going to be possible. However, she was admitted to study mathematics, which she liked and did well in. And the boys did not want to go to university, and so they learned a trade of their own will.

What kind of person was your father-in-law Jan Patočka?

He was an outstanding person. I mean outstanding literally, a person whom you could not overlook. An incredible talent in many ways: an excellent musician, an amusing comedian. He recited beautifully. Germans were amazed at his knowledge of the German language, even though it was a bit old-fashioned, and when he arrived in France for the first time as a foreign student, he was first in French composition.

What was he like as a philosopher?

We sincerely liked one another, even though my attempts at philosophy led me in a slightly different direction. Husserlian phenomenology and epistemology as a whole, the study of perception and the acquisition of knowledge, seemed very abstract to me. On the other hand, we both shared a strong interest in history. However, if I can count myself among Patočka's pupils, then for me he was a peerless model of philosophical conscientiousness and erudition.

When Jan Patočka died, and it is said that this was in connection with bullying and interrogation by the StB (State Security – secret police), how did you as a family perceive this?

At the time he was the only functioning spokesperson, because Václav Havel was in jail and they were monitoring Jiří Hájek day and night, and so he had to take care of everything.

But they took him away daily for interrogations.

That was only later. We all went for interrogations, but after he met Dutch Foreign Minister Max van der Stoel, this infuriated the StB so much that they took him away for some very long interrogations. The last one lasted 12 hours. There were several StB agents present. They posed a question, he answered, and they started all over again, as though he had said nothing. And so, in this way they tormented and exhausted him for 12 hours, then they brought him back home, and because he was weakened by flu, he had a stroke in the night. He was in hospital at Petříny for a week and he died there after a second attack.

But this was soon, because Charter was founded in January 1977, and he died in the middle of March.

This was certainly not convenient for the Communists, because this was really a big disgrace and a big blow.

How old was Patočka when he died?

He was just under 70. He was born in 1907. It was premature, because he was actually a healthy and pretty strong person.

They simply killed him.

They shortened his life.

But that funeral was crazy. A noisy helicopter hovering over the graveyard and on the other side of the graveyard wall motorbikes revving their engines at the StB's command so that the priest's words could not be heard.

When Jan Patočka died, I went straight to the priest of the Church of St. Margaret in Břevnov and arranged the funeral. When the StB agents came and wanted to do this differently, then I told them that it was already arranged. They wanted the funeral to be on the second or third day at six in the morning!

What, then, was the significance of Charter 77? In the end it was signed by 2,000 people, but this community was broader when you take into consideration people who sympathized or cooperated with the signatories.

When we initially signed the Charter, there were 240 of us. In the period up to November1989 it was signed by 2,000 people. The Charter did not help the domestic situation in Czechoslovakia; on the contrary, it provoked and enraged the hawks within the StB, who started to persecute people even more. It infuriated them a lot, and they tried with all means to suppress it in some way.

It had an undoubted significance in making it clear to everyone in the West that not everyone here was a communist. This was an important matter. Similarly to during the war. The Charter had a big impact abroad. The composition of the Chartists here was a very chance matter, because it was not possible to organize anything. The StB had this in their hands; they certainly knew in advance that the declaration of the Charter was being planned, but they did not do anything to prevent this, because they wanted it to take its course.

For me the Charter was significant in that I became acquainted with some people from outside my own circle, for instance with Petr Uhl or Petr Pithart, and to a certain extent with Havel. The interrogations were unpleasant, but I personally did not encounter any brutality; they did not drive me out into the woods or beat me up.

But they intimidated and imprisoned many Chartists, for instance members of the Committee for the Defence of the Unjustly Persecuted (VONS).

First of all, they assessed whom they could force to emigrate, and they concentrated on these people; for instance, they persecuted Ivan Medek a lot. They drove some people out of Prague and left them in the woods or even tied them to a railway track.

And what if a train came through?

They evidently arranged this so that nothing happened, but the person in question could not have known this.

When the revolution broke out after 17ᵗʰ November 1989, it was important that the Chartists were prepared to cooperate and that the dramatic events in the attempt to topple the communist regime had some kind of political scenario.

I think that it was important that a certain group of people had undoubted authority outside of the communist circle. And the common aim was the defence of human rights; everyone agreed on this. At the end of 1976, before the declaration of the Charter, more than half of the

The Prague Ten – imprisoned representatives of the Committee for the Defence of the Unjustly Persecuted. Upper row from left: Václav Havel, Otka Bednářová, Petr Uhl, Kamila Bieliková, Jiří Němec; lower row: Ladislav Lis, Jiří Dienstbier, Dana Němcová, Václav Benda, Václav Malý.

signatures were gathered by Zdeněk Mlynář, a former communist. And people then reproached us for cooperating with communists. However, Havel and Patočka as spokespersons for the non-communist part of Charter had a considerable amount of legitimacy.

What role, in your opinion, was played by Václav Havel in our history in the second half of the 20th century?
Havel is an incredible figure, comparable with Masaryk precisely because he succeeded in doing so much himself, because he was only one and unique. Both brothers, Václav and also Ivan Havel, were brought up from early childhood with the expectation that they must prove themselves in some way, even though it was not the custom in the Czech lands for children to be brought up to perform. I greatly esteemed Václav; he was unusually modest and had an exceptional ability to bring people together. When we were sitting somewhere and arguing, Václav was capable of sitting in the corner, listening and remaining silent. And when in the end he formulated his opinion, the debate ended.

Were you involved in the underground seminars?
Yes. Sometimes people talk about an underground university. However, people could say that then when they needed to give themselves some encouragement, but in fact there was no university. Primarily because these seminars did not lead to systematic work.

The people who attended them had more than enough on their plates, and it was not possible to expect them to do any homework. So, as I experienced these seminars, once a week

we would meet and read some difficult text, which at the same time we would translate. This seemed important to me, because the text could not just be gulped down, and everyone had to give it some thought.

In one such seminar we read Nietzsche's *Zarathustra* for years, over and over again. We all looked forward to this, no one examined anyone, and there was no homework. Many of us had already read this text before as romantic literature, but in the course of this shared reading the depth of this text became apparent below the slightly bombastic rhetoric. But this was not a university.

So, private apartment seminars.
Yes, these were lectures, regular seminars. We each learnt a lot there – one person from another – because they were attended not only be students and people who had not been able to complete their university studies, but also by the kind of people that you do not meet too often at university. But we all wanted to learn something, to think freely.

This seminar about Nietzsche was attended by an entire generation of philosophers who then went on to teach at the faculty: Neubauer, Kouba, Kratochvíl, Petříček. We met in various apartments, Jiří Němec and Daniel Kroupa also came along, several times we invited Patočka. Kroupa for years selflessly led a more systematic seminar specifically for young people.

Occasionally I used to visit Ivan Havel's very interesting Monday meetings. Another seminar was hosted by Petr Rezek, Ivan Chvatík supervised a seminar at which Heidegger was translated and Doctor Kraus a group translating Euripides. And sometimes I went to Zdeněk Pinc's seminar, held in his romantic home in Vyšehrad.

But this was some kind of resistance to the official philosophy, Marxism-Leninism...
Yes, after 1968 there was no longer much discussion about Marxism. However, you had to make a choice: either to take part in the dissent and reckon with interrogations and house searches, or to try and provide some kind of education which people would not be afraid to attend. I was no hero and we had children, and so I tried to avoid conflicts. That is also why we did not make any secrets: no ciphers or even passwords. Of course politics was discussed, but it was not the main topic. We all enjoyed attending these seminars; this was an oasis for us.

An oasis of the spirit and of truth and freedom.
Simply a place where people could trust one another, and think and talk freely.

After the massacre of students at Národní třída (National Boulevard) on 17th November 1989 the political situation changed from one hour to the next.
Even though I attended quite a few various events, I was not at the march on Friday 17 November, because I was accompanying an American TV team. Our children came home in the evening with a lot of bruises, and I told them: Well, you took quite a beating. I spent the Saturday at Václav Benda's, and when he told me about what had happened at National Boulevard, I still remained sceptical.

But this was a completely different kind of beating.
It was different, but still I did not see anything – possibly because I was not there. However, when all of a sudden the situation overturned, I could hardly believe how obtuse I had been.

My generation was already tired from that eternal waiting for when it would all crack and fall apart. After 1948 people thought that the communist regime would not last any longer than the next plum crop, then came various astrologers and soothsayers: someone looked forward to 1984 according to Orwell, and on 28ᵗʰ October 1989 (anniversary of Czechoslovakia's foundation in 1918) there were still evidently not enough of us on Wenceslas Square. And you almost instinctively stopped yourself from entertaining such hopes, in order to avoid being disappointed later. When in May 1989 someone told me that Václav Havel would be president one day, then I laughed at this.

But the situation abroad was well disposed to this change: Gorbachev's perestroika, the fall of the Berlin Wall, and so events then got into motion unexpectedly quickly.

Yes, the system was already evidently eroded. In September they allowed me to visit Austria for a couple of days, and the customs officers at the border found a typescript in my bag, examined it – and returned it to me. Something unheard of earlier. When Civic Forum was founded, I went to their HQ at the Magic Lantern theatre a few times. I also went to Olomouc, where they wanted to get some advice about how to found a branch of Civic Forum. But I saw that there were enough active people, and so I returned to my employment and started to plan the renewal of the famous pre-war *Přítomnost (Presence)* magazine. In the spring I left computer programming and took up a post as its editor.

Then my colleagues from the institute told me that I must stand as a candidate for parliament, because there were too many former communists on Civic Forum's list of candidates. At first I balked a little, but then I discussed this with my wife and I said that I would. When we then conducted the election campaign, people really did ask everywhere: Which of you is a former communist? I mostly held my meetings together with Charter 77 signatory Bohumil Doležal, and so we did not have any problem.

You became a parliamentary deputy and in 1998 education minister. Tell me what you think about the current Czech education system.

I think that after it got rid of those ideological pressures, then it is not so bad. Yes, it is conservative, but conservative schools are not the worst. In practice it is teachers and to a certain extent school heads who make the education system, and there are more than 200,000 of them. The ministry can spoil a lot of things for them, but the ministry's main task is to get money. Reforms should be done carefully, so as not to needlessly complicate life for pupils and teachers. To use the words of Hippocrates: first, do no harm.

But the Czech education system is the target of constant and long-term criticism.

This is possibly rather a case of people moaning and cursing, which mainly damages the authority of teachers and by doing so utterly damages education. There are not many competent critics, and a parent who curses a school in front of children has no idea how much damage he or she is doing by this. Ten million citizens – this makes roughly 15 million experts on education who understand everything. And meanwhile a teacher essentially needs a certain respect in class and definitely a better salary so that he or she does not feel devalued and does not have to seek other work to make ends meet.

When you consider that a teacher has to study university for five years and then has a monthly salary that is hardly average, this is not very good. Surprisingly, there are still teachers who are

constantly seeking for ways to teach children better, however pampered they are by the moving pictures of the television and the internet.

Democracy must be cultivated every day, and this has not happened here in the Czech Republic. Citizenship has not been systematically taught here, as it was for instance in Germany after the war. I regard it as a major failure precisely on the part of the Education Ministry that this was not required in syllabuses, that emphasis was not placed on this.

It is not so simple. The communists cultivated their 'people's democracy' in such a way that everyone became sick of this. It was always included in syllabuses, and from the 1990s there were also new textbooks. But it is not enough to teach democratic citizenship; people must be nurtured to this, and that mainly by behaviour and providing an example. The teacher must be a democrat in order to be able to persuade students of the advantages of democracy. However, because it is also necessary to have exams and give marks, then some teachers find it easier to limit themselves to such 'facts' as the electoral system and the number of deputies.

But a nurturing for citizenship was not emphatically supported and required.

And how would you like to require this? Citizens are nurtured for citizenship by starting themselves to care about freedom and justice for other people as well, just as good teachers do this.

But how many such excellent teachers are there?

Possibly the same number as excellent doctors, artists or journalists, possibly even slightly more.

As soon as you start to force on teachers something that they do not want, the result is a farce. Even young children quite quickly notice what their teacher really thinks and what not. I would be unable to teach children, and that is why I so esteem good teachers. However, I travel around quite a lot giving lectures at grammar schools on aspects of philosophy that are closely related to politics, for instance freedom and democratic institutions. Students listen carefully, and the better the teachers they have, the more carefully they do so.

What task did you set yourself as education minister?

I succeeded in establishing the Youth Council, a kind of central board of various youth organizations which makes decisions on the allocation of state subsidies – without noisy quarrelling and without corruption. I also succeeded in finding a compromise so that parliament finally passed a new law on higher education. I am not sure whether the more recent law passed in 2016 is going to be an improvement on the previous one or not – I just do not know. I did not succeed in getting training for trade apprentices back on its feet. I regarded this as my own special task, because I was the only Czech education minister who himself had learned a trade and also performed this trade.

Since 2013, when Zeman and Babiš came to power, there has been a twilight of democracy here in the Czech Republic. It is quite enough that Prime Minister Babiš is a former agent of the StB secret police and is the subject of a criminal investigation for fraud, while at the same time receiving EU subsidies for his companies. In addition, as the owner of two daily newspapers and two radio stations, he is in a colossal conflict of interest. Why has populism gained such popularity recently? And this is so over the entire world.

It is not over the whole world...

And what about Trump in America?

Trump is possibly a populist, but it is a tribute to the strength of American democracy that not even he threatens the freedom of citizens. In Germany they may have populist parties, but not in the government. Macron in France or May in Britain are definitely not populists. Democracy must assume that a majority of people value freedom. But for a large number of people security is their primary concern, and they do not care very much about anything else. And such people support in elections shameless politicians who have previously succeeded in frightening them. This is also a reason why voting in elections should not be compulsory, because this merely increases the share of such 'weed' votes that do not express a political opinion, but merely provoked fear.

Secondly, there is a big question as to how much long-term peace and prosperity have contributed to this state of affairs. During the former regime we citizens had a common opponent – communism. And the West had an opponent – the Soviet Union. The common threat of communism was undoubtedly one of the factors that supported European integration. However, after 1990 this threat disappeared and there is no longer any external force pressing Europeans into a bunch. So, the question is whether democracy can be maintained long term without any major conflicts. This is something that bothers me…

Without what kind of conflicts?

To put this another way: whether it is necessary for us occasionally to get a good collective bashing.

There are an increasing number of people who take for granted a good material standard of living, but they still want more and more, and they are not interested in anything else. They want someone to fix it so that they can work little but still enjoy a good standard of living. Or as we used to say here in communist Czechoslovakia: 'Work like a socialist and live like a capitalist.' This is a natural human inclination, it used to be called hedonism, and this inclination tends to gain ground in democracies.

You are a Czech. You grew up in this country, in this culture. How do you perceive the fact that you are a Czech?

Quite similarly to the fact that I was born in Prague, that I have a good wife and three children: as an important attribute of my person.

I first learned to speak in the Czech language and I have lived for 80 years in the Czech culture. Or possibly it would be more precise to say that I have lived from the Czech language and from Czech culture, because what would I do without these? I value both, and because I can find a reliable foundation in them and in my nation, I do not need to be afraid of the other ones.

In view of this I bear a certain responsibility for the Czech language and Czech culture and I should take proper care of them. This means defending them not only against external enemies, but also against domestic louts, boors and fools. I should be one of those who propels language and culture in a positive direction and pulls it from somewhere.

One of my specific tasks I regard as being to break down Czech small-mindedness, the kind of way of thinking in a country hemmed in by mountains: there is nothing beyond them. My grandfather was a big supporter of Masaryk, a mathematician and an astronomer, and one time he said to me: You know, after 1918, when Czechoslovakia was founded, Prague became a big village. He saw this from the point of view of his science; in such a small country all of a sudden

anyone could be a champion. Up until then we had been part of the Austrian monarchy, the university in Vienna was also in the same country and Czechs had to try hard. Whereas today we may think: We are Czechs, and whoever is not a Czech can go and get lost.

You have a command of foreign languages, but you evidently think and write in Czech. Are you fond of the Czech language?

Czech is like the air that I breathe. Perhaps I also like it, because it annoys me when people make a nasty mess of it, for instance by overuse of the passive voice. Even when you learn some foreign language, and even if you already think in this language, then nevertheless – as you say – it is still a foreign language. However, when you translate, you sometimes ascertain that some things can be expressed better in French or in German. Of course there are also cases in which the opposite applies, but as a Czech speaker you do not have any problem with these.

Are you glad that you are a Czech?

That is something that you do not ask someone about.

But you have spent your entire life here, half of it in totalitarian regimes. On the other hand, there was an amazing culture here.

Culture is not a bath which you lie in. The word culture is derived from the Latin word colere, which means to cultivate. Culture is something that becomes hollow and perishes, when we cease to take care of it, to engage for it.

Just like democracy.

Yes, precisely so.

Interview conducted by Olga Sommerová 13. 12. 2018, Prague.

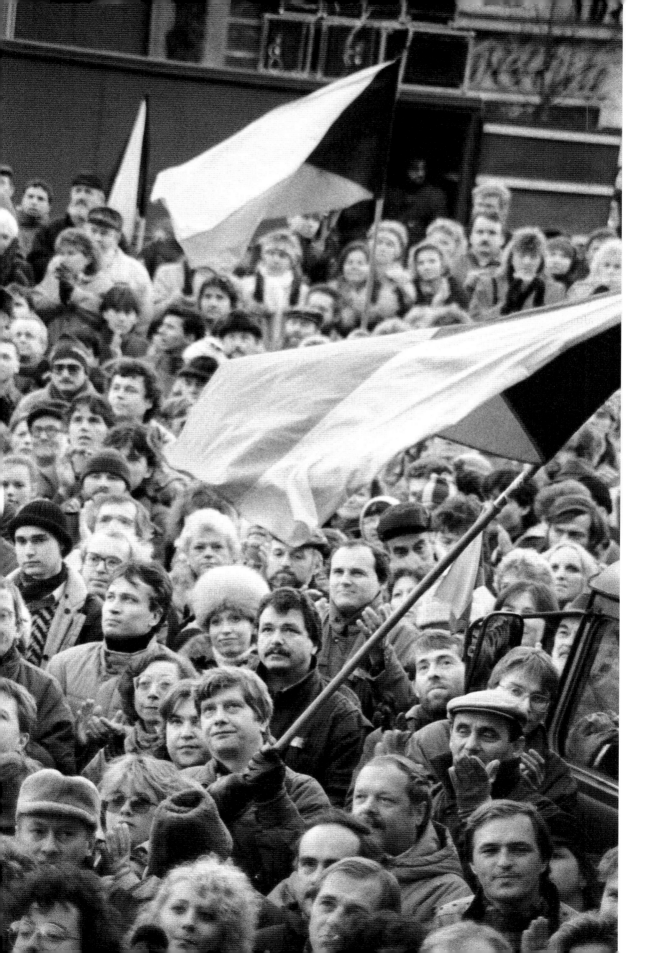

DANIEL KROUPA

During its existence Czechoslovakia was occupied twice: from the West and then from the East...
The Bohemian massif is a geopolitically significant place, which has been the subject of various discords. But for a long period we were successful in defending our independence. In the 20th century we found ourselves between two grindstones, Germany and the Soviet Union, both of them founded on totalitarian principles. Unfortunately, our leaders did not succeed in evaluating the situation correctly and failed to establish alliances capable of defending us effectively.

What influence did the Prague Spring and the consequent Russian occupation have on our history and the national consciousness?
Many historians view the Prague Spring as a movement that had the unequivocal support of all democratically thinking Czechs. This is somewhat misleading. Already before 1968 I did not believe a word the Communists said. One year before they had wanted to expel me from school because I wrote an essay containing some kind of criticism of the regime, and they did not take kindly to this. In 1968 these same Communists, who had wanted to expel me, all of a sudden declared their allegiance to a reform current and announced a democratic socialism. So, just how was I supposed to believe them?

So, you did not believe them for the entire period of the Prague Spring, that is the eight months from January to August 1968?
I did not believe them, but of course I supported these reformists in the clash with the Stalinist conservatives. But only up until the moment when in August 1968 the representatives of the Czechoslovak state and the Communist Party came back from Moscow, where they signed the shameful Moscow protocols. Naively I was at Gorky Square (today Senovážné), where the parliament was located, to welcome them home. When I heard the short speech by Josef Smrkovský there, I felt sick and I wanted to throw up, because once again they had betrayed us. But even previously I had not had the slightest illusions, because if the process of democratization was to continue, then a plurality of political parties would have to have arisen. And how could Dubček and his adherents allow any such thing, when article 4 of the constitution guaranteed the leading role of the Communist Party?

When I founded the Club of Engaged Non-Party-Members, known as KAN, Ivan Sviták pointed out precisely this contradiction and asked whether therefore there would continue to be two categories of people: the ruling Communists and the subordinated others. In short, the ideology of the 1968 Prague Spring contained such contradictions. On the other hand, I terribly enjoyed the freedom that all of a sudden emerged. I was convinced that it was necessary for people to get together and not allow this freedom to be taken away. Or at least to resist for

← Wenceslas Square in Prague during the period of the general strike, 27. 11. 1989 (ČTK / Pavel Hroch)

as long as possible, to demonstrate, to protest against the onset of normalization and the suppression of freedom. That is why I took part in various protest events and in November 1968 I participated very actively in the student strike. A year later, but in smaller numbers, we had another strike. I also participated in the demonstration on the occasion of the first anniversary of the occupation. On Wenceslas Square on 21ˢᵗ August 1969 the police intervened brutally against the demonstrators. They were even some deaths. One year later I also tried to take part in a demonstration, but by then there was already a decline and only a few of us turned up. What the reformist Communists regarded as support from the entire nation for democratic socialism, was in fact support for the freedom which the internal party conflict had enabled.

When the Russians arrived, you, like me, were 21 years old. For me this was an absolutely fundamental and determining moment of my life. This marked our generation, and also the previous generation.

I experienced the Soviet occupation as a terrible humiliation. I even considered some form of violent resistance towards this occupation, but in the end I came to the conclusion that violent resistance would only strengthen my opponents. You were driven into a corner primarily by the fact that the Soviets had justified their intervention by saying that there was a counter-revolution in Czechoslovakia. Any and every case of violent resistance would be interpreted as counter-revolution. So, this path was closed. I also considered other forms of resistance. The resistance that took place in the first week after the occupation was quite enchanting, but not very significant. It was necessary to prepare for many long years of resistance.

This January it is fifty years since Jan Palach immolated himself. How did you perceive his act?

I absolutely disagreed with this act. I was convinced that it was necessary to resist actively, and in the first moment I took this as meaning that he had given up; even though he had carried out a demonstrative act, I did believe that this act would have any significance. Only over the course of time did I come to realize that some such acts transcend a given moment and have a permanent significance.

And this is the case of Jan Palach, because he inspired us, not by this suicidal mission, but by this resistance. In the end the year 1989 started with Palach week, with the week of demonstrations called to commemorate the 20ᵗʰ anniversary of his act. And this week of civic resistance was a prelude to the Velvet Revolution.

In April 1969 Gustáv Husák took over power, replaced Alexander Dubček and initiated the 20-year-period which we call normalization.

For me normalization was an even worse experience than the August occupation in 1968. In the final instance the Soviet army merely did what came naturally for it; communist totalitarianism simply did not want to let go of a conquered territory. But the fact that many people in Czechoslovakia started to bow down in the face of this, filled me with despair. And this was often a case of people who in 1968 had styled themselves as fighters for democracy, and all of a sudden they were appearing on television with their heads bowed, publicly confessing their faults and saying that they had been 'misguided'. For me this was even more humiliating than the occupation, because here all of a sudden we had betrayed ourselves. When in 1975 I then joined TESLA OP company as an advertising editor (up until then I had worked either as a shopfront cleaner or as a stoker), then I suddenly ascertained that the way in which the Communists motivated their

workers were not any great pressures or threats, but quite simply money. For a couple of hundred crowns more people participated in communist events, even though they did not actually have to do so; when I refused to attend these events, then actually absolutely nothing happened to me.

You said that we lived in freedom for a long time. But this was actually only 20 years.

We enjoyed freedom for 20 years during the First Republic, and now we have lived in freedom once again for 30 years since the Velvet Revolution. And so, for our 100 years of existence it is 50:50. I would say that in those periods of freedom – and sometimes in the gaps in periods of unfreedom – we have succeeded in quite decent performances in the fields of sport, culture and education. When we look at how many books were published during the First Republic, at how an effective state administration and education system were successfully built up in the whole of Czechoslovakia, then I think that these are all things of which we can be proud. Even if we look at these 30 years since the Velvet Revolution, then the achievements have also not actually been so small. In some ways the situation was much worse than when Masaryk and his friends founded the Czechoslovak Republic, because Austria-Hungary was not a totalitarian state, but was rather a state with a developed legal system, in which even a poor person could assert his legal rights and obtain justice in a dispute with a rich person. This is not the case in totalitarian regimes. Secondly, the First Republic was founded in the environment of a functioning civic society. After the Velvet Revolution there was no independent civic society, because the communist regime had destroyed it; it had atomized the nation, and as far as any societies existed, they had to be directed by the Communist Party in accordance with article 4 of the Constitution. After the Velvet Revolution civic society was created once again, and I would say that it has made great progress in how it has developed up until today.

But Charter 77 was a civic society during the communist totalitarian regime.

Charter 77 was the seed of a civic society, but a tiny one, because its membership was less than 2,000 people. Of course, around Charter was the milieu of the so-called grey zone, which cooperated with Charter and without which Charter could not have survived. So, let us say in this way some 10,000 people were active. But this could not of itself function as a civic society. It was, along with the church, one of the elements that resisted this regime.

In the 20th century a lot of valuable people fled the country to escape the totalitarian regimes. The loss of elites has been constantly repeated in Czech history.

Yes, this is a phenomenon that is repeated in Czech history. Already after the Battle of White Mountain in 1620 many elites were forced to leave. Later, it was the more educated people who left Czechoslovakia, after 1938 and 1939 in particular people of Jewish origin. Then, people left after the communist putsch in 1948, and there was also a big wave of emigration after the Russian occupation in 1968.

Many Czechoslovaks left who excelled in their fields, and we could have been, if not one of the superpowers in these fields, at least one of the powerhouses: for instance, in computer science. And so, we have always gone back to the beginning. We have lost a large number of excellent people who have gone on to be successful elsewhere in the world. Some branches of knowledge completely ceased to exist, because they were banned for ideological reasons. This was the case of philosophy. After 1948 it was only possible to teach philosophy within the framework of Marxism, merely as a complement to Marxism, and other, non-Marxist directions

Participants of the Kampa Academy in the garden of Ivan and Václav Havel's cottage at Hrádeček

were not allowed. Even at theological faculties students had to become acquainted with Marxism, and philosophy was extremely restricted. During the Prague Spring in 1968 some leading personalities, such as Professor Jan Patočka, were successfully brought back to the universities. However, after the occupation, when the process of normalization started, there was a threat that the teaching of philosophy would once again be halted. And so, this teaching moved to private apartments.

In the 1970s and 1980s philosophy bloomed only at seminars in private apartments. You were a part of some of these.
There were a number of these seminars. I myself first came to such a seminar, when they banned the Theological Seminary at Jirchář in Prague. Then a group was formed under the leadership of Jan Sokol, which met in the cellar of a villa in Břevnov. It was called Kecanda and lasted for many years. The study of philosophy at this group had a relatively high professional level. Various seminars also existed which were rather aimed at providing teaching and discussion for general interest. Therefore, some friends and I tried to found a seminar that would fulfil certain professional standards. One of these was the Kampademie (Kampa Academy), which initially took place in my apartment, when we lived in Všehrdova Street near Kampa, and finally moved to the Všehrd (Huť) Mill. I founded another such seminar in 1978, after the death of Professor Jan Patočka, with the aim of preparing the younger generation so that they would be capable of taking over and further developing Patočka's philosophical legacy. This was a really systematic educational seminar, which was intended to substitute for university education. Over a period of 12 years roughly 50 students went though this course. Later on some other colleagues, for instance Ivan Chvatík, became involved in the seminar's activities. They took on students from me and educated them further. Philosopher Ladislav Hejdánek founded his own seminar and Petr Rezek also developed various activities. When necessary, we cooperated.

It can be said that in the 1980s philosophy really started to boom here, because philosophers from Oxford started to travel to our seminars. They were gradually joined by philosophers from other universities. There were personalities who represented the top echelons of philosophy at that time, such as Charles Taylor, who was the first, or later Paul Ricoeur, both of whom travelled here regularly.

Jacques Derrida also travelled here, but the State Security (StB) did not even allow him to give his lecture and they accompanied him out of the country. Roger Scruton and Jürgen Habermas,

whom I showed around Prague, also visited. Some other experts who later went on to become major figures also lectured here.

Were there more of these apartment seminars, not only in philosophy?

There were a whole range of these apartment seminars. I know that the historians had their own seminar and the sociologists also gathered around sociologist Miloslav Petrusek. Christian theology was also on the black list, and so there were many private theological seminars. Some seminars even tried to provide teaching that was linked to foreign universities in such a way as to capable of offering their graduates fully-fledged university degrees. So, it can be said that, thanks to this foundation, it was possible to revive philosophy relatively quickly after the Velvet Revolution. However, to be truthful, even after 30 years we have still not fully made up for this lost ground.

Why did you sign Charter 77?

The primary motive was personal, because one of Charter's three spokespersons was Professor Jan Patočka. He was my teacher, and I had the impression that I could not leave him alone in this, that it was the duty of a pupil to support him. But there was also a second motive here, and this was the conviction that it was necessary to make a stand in some kind of way against the communist regime. However, at the moment when I signed the Charter, I had no way of knowing whether this stand would merely be self-humiliating, or whether it was going to have some significance.

What did you ascertain when looking back later?

The significance of Charter 77 was much more spectacular than I had initially thought it would be; it was more spectacular than any of us could have even imagined at the beginning. Even before, there had been various activities that had achieved a certain response, but Charter 77 created a real community of people who cooperated even in spite of their various political opinions, ages or professions – regardless of all differences. And these people showed solidarity with each other, mutually supported each other and helped each other as far as possible. In other words, this was not a case of any kind of organization, but there was something more there than an organization. I think that, without this broad human scope, Charter 77 would not have survived. At the same time it must be said that the Chartists did not form any unitary whole, but there were small groups that were mutually interconnected through individual people. And so, for instance, I did not come into contact with people from the milieu of the reformist communists until the second half of the 1980s. Up until then I had not known any of them. However, I knew about them, and they knew about us. For me the most amazing thing was that the Charter 77 community was comprised, on the one hand of people like Catholic priest Josef Zvěřina or Professor Růžena Vacková, who had spent the 1950s in communist prisons, and on the other hand by people like Oldřich Hromádko, who had been an StB officer and in the 1950s had been responsible for guarding those political prisoners. He had been commander of a unit called Jestřáb (Hawk), who were the people who shot at prisoners trying to escape. However, after 1968 he parted ways with communism and signed the Charter. It is almost unimaginable that these people could form one community. In all probability they never met personally, but at the moment when the StB took action against one of these small groups, the other groups would come forward to express support for the group being persecuted.

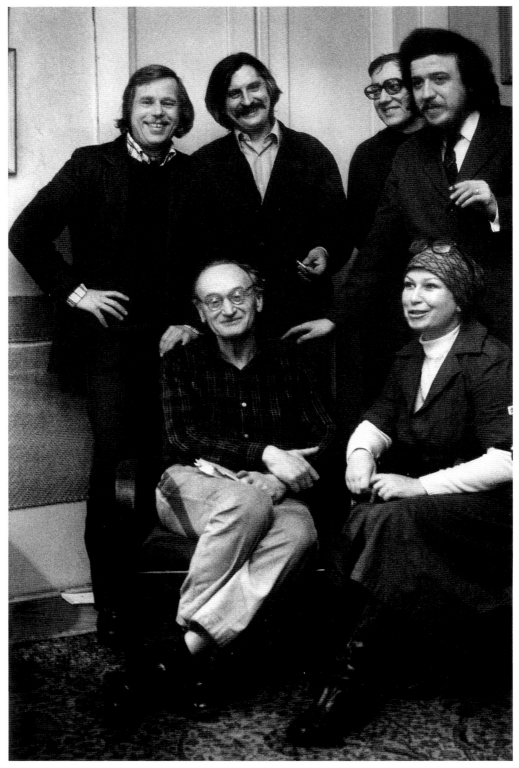

Rotating spokespersons of Charter 77 – Upper row from left: Václav Havel, Jiří Dienstbier, Ladislav Hejdánek, Václav Benda, sitting: Jiří Hájek and Zdena Tominová (Ondřej Němec)

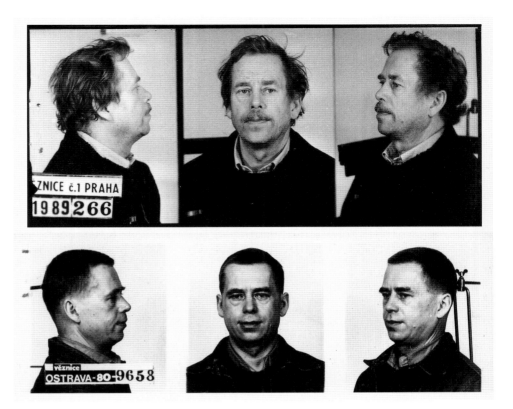

Václav Havel – photographs from prisons in Prague and Ostrava

In that atmosphere of desolation for those 20 years that are called normalization you Chartists represented a light that somewhat denied that total shame of the nation that had bowed down and bent its backbone. Was this a ray of light?

It was. The most important thing was that Charter 77 existed at all. Charter was a result of the fantastic idea that the communist regime, which had accepted its international commitments in 1975 at the Helsinki Conference on Security and Cooperation in Europe, would not be capable of liquidating this community in one swoop, because if it did so, then it would evidently be breaking its commitments; that, even though it would be able to bully individuals, Charter 77 as a whole would remain. And this assessment was in the end confirmed. Secondly, the very existence of Charter created an environment in which it was possible to freely create. In this environment samizdat publishing developed: not only various book editions, but also various magazines. In this environment an independent culture developed, which from today's point of view does not always meet very high standards, but it was important that it was independent and it existed. And in the final instance this was a sign that not everyone had submitted to the occupation regime and that possibly there would be more such people who in certain circumstances might be willing to express their opposition publicly.

One part of Charter 77's was the Committee for the Defence of the Unjustly Persecuted, known as VONS, which issued communications about people who had been unjustly prosecuted and imprisoned. Five people from this committee, among them Václav Havel, were sentenced to prison.

The environment of Charter 77 created the soil for the foundation of other such initiatives. For instance, in the 1980s there was the Movement for Civic Freedom and various peace initiatives. The Chartists also represented fleeing hares whom the police dogs chased after, and so they

created a little bit of free space for other people, because the StB did not have enough time to persecute the others. Neither should we forget this role played by the dissidents.

What role, which was then crucial especially in 1989, was played by Václav Havel?
Already in the mid-1980s Václav Havel was the undisputed democratic leader not only of Charter 77, but also of almost all other initiatives. He himself was unhappy about this; it can even be said that he was sometimes even in despair about it. I myself experienced several times how he became agitated, when people travelled to see him at his cottage in Hrádeček and wanted him to approve some activity. He said to me: 'Why don't they decide themselves. Why do they need my blessing for this? After all they are free people, and I am not some kind of authorization department.' When I spoke with him in 1988 about the fact that many people saw in him a possible future president, he became very annoyed and said that he had absolutely no such wish. I also had a number of bizarre experiences with him, when people from the milieu of, what I would call, religious sects tried to attach themselves to him, because they saw in him a kind of future spiritual leader. Of course we can laugh about this, but at the same time this shows that even these people felt that there was simply no other such personality here who would have been capable of welding together this wide range of various currents.

Is it at all possible to calculate the moral and material damage of the 40-year-long communist regime? Is it at all possible to express in numbers how much this country, which was materially and also spiritually rich, was destroyed by this regime?
We know that the loss has been enormous, but we do not have any means of measuring this loss. However, the loss is demonstrated in its consequences. At the moment when we attained freedom – that is, shortly after the Velvet Revolution – some people came to power who declared ideas which were actually normalization ideas. The moral value of the Velvet Revolution was replaced by the conviction that everyone should pursue his or her own interests and career. This was a strategy that was based on a saying, which everyone laughed at, but which at the same time everyone accepted as true: that the most important thing is money. In short, the widely accepted conviction that it is mainly a case of a person pursuing his or her own interests and acquiring as much as he or she can for himself in this social life.

This demoralization brought Václav Klaus to the fore, and then also Miloš Zeman and today Babiš. In the end these election results are a result of these ideas.

I was also in favour of introducing a market economy as fast as possible, but at the same time I could not agree with the market economy being presented as the basis of the moral order. After all it is a big difference when someone engages in business in order to create new things, new services, and when someone engages in business only in order to grab as much as possible for himself or herself. This selfish spirit that entered into this immediately at the beginning poisoned the newly developing system. It is only today that for the first time you come across entrepreneurs who are willing to give a lot of money to culture, charity and similar things, without having any thought of personal gain from this.

How could it happen that immediately after the Velvet Revolution, when we were still naively celebrating our newfound freedom, the national wealth of this country was quietly being stolen?
My opinion is that the national wealth was not stolen, because to a large extent it already had been stolen. The privatization, which today is criticized, had to be carried out as quickly as

possible, in order to prevent the communist nomenclature functionaries who were still officially in charge of companies from robbing these companies, which is what happened in Hungary. In Hungary the communist company directors actually managed to get one step ahead of privatization by simply stealing the companies for themselves.

And here this was not the case?

Here there was at least a chance, firstly in the coupon privatization, when people had the chance to at least partially participate in privatization, and mainly in the restitutions, in the course of which many properties (often in a desolate state) were returned to their original owners. Of course those former ruling Communists had an advantage, because they had better information, access to funds, and they were mutually interconnected. You know, this is a process that has not yet been sufficiently mapped.

I believe that, when we look back, it will be ascertained that, taking into account how badly the economy had been devastated by the Communists, it was successfully put back on its feet thanks to quick reforms. We should be aware of this in comparison with Poland, where the economy collapsed, there was massive inflation, money lost its value, and many people were unable to purchase even basic goods. In this period fundamentally nothing so very bad happened here in Czechoslovakia. And so, the process of economic transformation must be evaluated objectively and with the benefit of hindsight. I did not agree with many steps of the privatization process. I was convinced that restitution must be in the first place and that companies should be returned also to legal entities. Further, I was of the opinion that we should then give preference to direct sales of companies, when it was really assessed that the purchasing party had sufficient means and also had a good project, and that only that property which remained after this process should be included in the coupon privatization process. Klaus succeeded in implementing the opposite approach.

What do you think about the thick line drawn under the crimes of communism?

In 1990, when I was elected to the Federal Assembly, I tried to push through a real settlement with the past. An important step was that we managed to pass the declaration (the author of which was Pavel Bratinka) that evaluated the communist regime as illegitimate and damnable. We wanted this to become literally a part of the legal code, so that the courts would then decide various disputes in the spirit of this declaration. However, we did not succeed in this, and this declaration remained just that, a mere declaration. During the Velvet Revolution the reformist communists from the Obroda (Renewal) movement played virtually no role. However, after the revolution, when they ascertained that Gorbachev was not going to intervene and hand over power to them, then they infiltrated Civic Forum and many other institutions, and after the first free elections they even gained control of a majority of functions in parliament and in the governments.

In other words, a stolen revolution.

Many people had the impression that the revolution had been stolen from them. What I want to explain here is why it was then so difficult to push through any kind of settlement with the past. After all, the people who were in those functions and who were supposed to deal with the crimes from the 1950s had either themselves participated in these crimes, or their parents had done so. Let me give a specific example to show how this took place. The prosecutor general

was Mr. Gašparovič and we requested him to immediately start investigating the crimes against humanity that were committed mainly in the 1950s. The prosecutor's office remained inactive. We passed a further resolution in parliament – and once again nothing happened. In the end we managed to get Mr. Gašparovič dismissed, and things only first started to happen after new prosecutor general Lauko started to act. During roughly 14 days he presented a report which at least mapped out what it was possible to do and what was not possible. However, not much time remained until the division of the state (Czechoslovakia split into the Czech Republic and Slovakia on January 1, 1993). In other words, the inactivity of various offices was caused by the fact that functions in the state administration were occupied by people who quite simply did not wish any settlement with the communist past and with the regime's crimes.

For instance, the Committee for the Defence of the Unjustly Persecuted (VONS) presented to the Justice Ministry a list of judges who had judged unjustly in the past so that these judges could be dismissed.
This was even worse than you say. This was not a case of dismissing these judges; no one dared to demand this any longer. This was a case of not reappointing judges who had participated in repression. And when I talked about this with Justice Minister Novák, he laughed in my face and pushed through their appointment.

Who was this Doctor Novák?
He was a politician for the ODS (Civic Democratic Party) and he was not himself a communist. However, by this time Václav Klaus was already firmly established as prime minister and he did not want any settlement with the past; on the contrary, he surrounded himself with people who were linked with the former regime, and not only with the Communist Party, but also with the StB.

When crimes remain unpunished, this demoralizes the nation.
When this crime is not even investigated and named. In the end you do not have to insist that old people who committed some crime in the past go to prison now, but this is a case of publicly pronouncing: a crime was committed here and we in a democratic regime reject such acts.

Is this not also what the slogan 'We Are Not Like Them' means?
'We Are Not Like Them' was a slogan that was used already during the course of the Velvet Revolution and it meant something else. It meant: we are not going to settle personal accounts with you; we are not going to use violence in order to intimidate you; we are capable of defeating this criminal regime without violence. But it is something entirely different when you request that the criminal justice authorities perform their duty and punish crimes. The main problem of making a settlement with the past was that there remained here an enormous mountain of crimes that were still not subject to the time limits in the statute of limitations, but the criminal investigation bodies remained inactive in pursuing these cases.

Only a very few of them were tried and convicted, for instance Ludmila Brožová, the prosecutor in the trial of Milada Horáková. I recorded her at the trial and asked her whether she knew that crimes against humanity are not subject to the statute of limitations. She had no reply. This old woman and a few other people were convicted, and that is all. And meanwhile these criminals live

in peace. Ladislav Mácha, the murderer of Roman Catholic priest Josef Toufar, lived peacefully in the Petřiny district of Prague until recently and had pretty much nothing to fear.

Just like Karel Vaš, the murderer of General Heliodor Píka, and many others. Or Miroslav Grebeníček (leader of Communist Party 1993-2005), who was a torturer of innocent people.

Why was Czechoslovakia the most loyal and most servile satellite of the Soviet Union?

I contend that the DDR (German Democratic Republic) was even more servile. But that does not excuse our servility. Unfortunately, this servility started already in the period when we still had some kind of illusion of democracy. In the period from 1945 until 1948, when – during the process of liberating eastern and central Europe – the Soviet Union took over a piece of Czechoslovak territory, Carpathian Ruthenia, and our politicians remained silent about this.

From today's point of view the liberation by the Soviet army in 1945 was at the same time an occupation.

A liberator does not behave in such a way toward a liberated state; it behaves in such a way toward a defeated country. Our politicians were servile toward the Soviet Union because they most probably had reason to be. They were afraid that the Soviets would crack down on them in the way they did with the Polish government-in-exile, which they did not admit to power at all.

Secondly, the myth that in 1946/47 the Soviet Union supplied us and saved us from famine, which were taught in school, and the illusion that the transfer from a democratic regime to a communist one was in accord with the law, this all created the feeling that we were not authors of our own fate and that someone else decided for us.

In the case of Austria it was shown that, when the Austrians succeeded in resisting, the Soviets in the end backed down. I am convinced that, if our politicians had acted more purposefully and strong-mindedly, then Czechoslovakia could also have achieved a similar status to that which Austria succeeded in attaining. But that did not happen, because the communists had too much support here.

There was also the tragic role of President Beneš, who failed to see that Stalin did not negotiate with anyone honestly.

The Russians were too strong, and unfortunately Beneš thought that it was possible to achieve some kind of compromise with a totalitarian Stalinist regime, that this would be some kind of half-communism. This stance actually shows that Beneš had absolutely no idea with exactly whom and what he had the dubious honour of dealing.

For the last five years we have been observing a twilight of democracy not only here in the Czech Republic, but also in the post-communist countries generally. Do you think that this is because the generation has now died out which experienced communist oppression and therefore had no desire for any government of the firm hand again? Or did the totalitarian virus establish itself so deep in our souls that it has not been cured?

I am not an a priori pessimist in this respect. What is happening now is connected with further social processes which cannot be derived from the virus of the previous regime, if by this virus we mean a certain moral stance.

What I have in mind is that our failure in the period when we had gained freedom almost for free actually consisted in the fact that we once again turned to those motives that some economists defended as being the motor of economic development. And we neglected some key principles without which democracy cannot function. These are primarily education, culture, moral upbringing. The most tragic failure I see in the absence of education for democracy, because after 50 years of totalitarian regimes our people not only lacked actual experience of democracy, but even had very distorted notions about how democracy functions.

The first thing that should have happened after the passing of the new constitution, and within the scope of the reform of the school system, was the creation of a developed system of education for democracy, such as really functions in Germany and many other democratic countries. The result of the failure to do this is that we have a young generation that has no idea what parliament is, that has no idea about its rights and freedoms, because these things are simply not taught in school. Unfortunately I experience this lack of knowledge every year at the university entrance exams for political science: young people turn up for the exams who do not even have the knowledge that children at primary school should have.

It is the case that democracy must be protected every day, even when some small thing happens. We are in a similar situation to that in Poland and Hungary; we are threatened by populism.
These are quite different cases here in the Czech Republic, in Poland and in Hungary.

In Hungary politics was ruled for a long time precisely by former Communists 'in new coats', many of whom had become rich in the wild privatization carried out in the years 1987–1990. Many of these former Communists then sponsored the Social Democratic political regime, which actually continued to serve them in their economic interests. The further process of privatization was also performed problematically, and the result was a widespread feeling of injustice, which Viktor Orbán and his party FIDESZ succeeded in making use of with a mix of nationalism and populism. In this way it gained an almost undefeatable position in elections.

The case is different in Poland. There the Social Democrats, who were communists in new clothes, collapsed after their second return to power. First of all Solidarity lost, because after taking over power it was not capable of effectively governing the state, or at least that is the way that it seemed to me at the time. Then the communists returned again in a new costume under the leadership of the agreeable Mr. Kwaśniewski, who later became president. A majority of Polish society which wanted a continuation of reforms and 'de-communization' was frustrated.

Initially the liberals led by Donald Tusk governed on the whole successfully, but the bitterness on the part of the overlooked section of society and its hatred toward what was presented as modernity was used – once again with a little bit of nationalism and traditionalism – by Mr. Jaroslaw Kaczyński, who created a strong movement that removed the discredited liberals from power.

Here, after Civic Forum, the ODS (Civic Democratic Party) ruled for a long time at the head of a coalition government. This government merely carried out needed reforms, some of which were very difficult. Nevertheless, post-communist economic elites established ties to these coalition parties and these elites here also used politics for their own enrichment.

And when Miloš Zeman (then Social Democrat leader) announced the Clean Hands campaign against this corruption, he attracted support from a large section of the population. He was successful in the election, but after the election he denied everything that he had declared before it. The Social Democrat (CSSD) Clean Hands campaign, which was supposed to be aimed against the fraudsters in the ODS, ended up with the so-called 'opposition pact' (by which the

ODS enabled a minority CSSD government in return for influential posts in the state administration). Ivo Svoboda, one of the asset-stripping fraudsters, was even appointed finance minister in this CSSD government. Svoboda was later convicted and imprisoned for economic offences. Zeman's promise that he would not privatize the banks under any circumstances ended with him selling the banks very quickly. Unfortunately, he sold all of them to foreign companies, and so today the enormous dividends from the Czech banks are paid abroad. Zeman also promised to enforce the payment of the debt owed by Russia. However, when in power, he 'unblocked' this debt by simply leaving most of the money to the Russians, and the Czech Republic was left to cry over its lost earnings.

In other words, the corrupt system continued and developed at an unprecedented pace. In this first phase this corrupt system was 'only' lobbyist – this means that corrupt lobbyists went around the corridors of parliament and tried to win over individual politicians for their purposes by offering personal bribes. This phase was then succeeded by a 'clientist' system, in which entrepreneurs already placed their own people in political parties and political functions. The corrupt system culminated in the oligarchic phase, in which the economic oligarchs founded their own movements and entered politics themselves (for instance, current Prime Minister Babiš and his ANO movement of 'Dissatisfied Citizens').

It is evident that the Russians are controlling politics here in the Czech Republic by means of a hybrid war, support for Zeman, support for Babiš, support for the oligarchs.
This already started in the first half of 1990s. We should be aware that by pushing through the completion of Temelín nuclear power station Václav Klaus was obliging mainly Russian interests. The economic calculations at that time showed that this building project was not only not essential for us, but that it was not even very efficient. Klaus also fought for the retention of a Russian monopoly on the import of petroleum and he wanted to privatize the Chemapol refinery, which was the extended hand of Russian Gazprom. And then a tough battle was fought within the government over whether we would also be dependent on the Russians for supplies of gas as well – God be thanked that Klaus was unsuccessful in this. At the time some ODS ministers were persuaded to vote against party leader Klaus, and he was outvoted on this matter.

At that time the ODA (Civic Democratic Alliance) opposed the Russian variant very strongly and argued in favour of the variant of Norwegian gas, thanks to which today we are not dependent on Russian gas. From the very beginning Václav Klaus also cast doubt on our country joining NATO and the European Union, even though as prime minister he could not go against the ODS party membership, most of whom held the opposite opinion to Klaus and were in favour of joining these institutions. Already at the beginning of the 1990s I had a very sharp conflict with him about this, even on television.

Miloš Zeman (current Czech president) is actually now following the same line as Klaus. It is my contention that precisely that 'unblocking' of the Russian debt has played a large role here. During this process Zeman must undoubtedly have gained some friends, who then supported him. It is known that some Russian firms are partly connected with the mafia and partly with the secret services. These firms financed some foundations, which then paid for various billboards supporting chosen politicians. With such support Klaus previously won elections and now Zeman has also won with this support.

It is interesting that Klaus, whom I personally regard as the biggest saboteur of the country since the revolution, and then Zeman were both connected with the Prognostic Institute, a communist-era economic forecasting institution, which was a branch of the KGB.

Not a lot is known about what went on at the Prognostic Institute. As far as I have been informed, for instance by Tomáš Ježek, I tend to incline to the opinion that a considerable amount of chaos ruled there, rather than the KGB. But some people at the Prognostic Institute undoubtedly did have contact to the KGB. After all double agent Karel Köcher (KGB/CIA) worked there, and he most probably did not entirely lose his contact to his comrades in the Soviet Union.

Why are populists so successful now? Not only here in Europe, but also in America? Trump has also apparently been supported by Russia for a long time.

I contend that here in the Czech Republic this was caused to a large extent by the fact that democratic political parties discredited themselves by the corruption which I have talked about. They presented themselves as the sole flowering of democracy and thus created an easy target which anti-system parties and movements were then able to use against these parties and against democracy.

I saw how this functioned in the Ústí nad Labem region. There no matter whom voters voted for, nothing changed. When the ODS won the election, then the Social Democrats were their partners and occupied neighbouring offices. When, on the contrary, the Social Democrats won, then they simply swapped offices with the Civic Democrats, and public contracts continued to go to relatives and other associated persons. Politics was not directed by voters, but by godfathers in the background. So, a nest of corruption became so established there that, when finally some movement that offered an alternative appeared, people were overjoyed.

And at the beginning Mr. Babiš's ANO (Movement of Dissatisfied Citizens) could have made a positive impression on people as a pleasant change, especially when Babiš stressed that he himself would never enter politics. But it turned out that he quickly changed his mind about this.

How do you think this inauspicious situation is going to develop? Since 2013, when Zeman and Babiš took up office (as president and finance minister respectively), the principles of the rule of law have been collapsing. Do you have some hope?

I think that the only hope is that the other, really democratic forces succeed in combining their efforts and creating a unified political movement that will win in the election to the Chamber of Deputies.

An important role in this bad situation is certainly played by various attempts to prevent this combining of forces. But this is an old strategy which was already used by the Soviet Union, which introduced disputes in democratic movements in other counties and supported its own favourites in these disputes. This is what happened in the 1970s and 1980s in what was then known as the Third World, and what we are witnessing today is the very same strategy, which continues to function and adapt to new technical conditions.

Democrats and more educated people have a tendency to be involved in constant polemics and disputes, and it is sufficient to pour oil on the fire and these polemics turn into conflicts, and so the opponent can rejoice. But I am an optimist in that I have observed how over the last few years energy has been growing in the nation and this energy is making apparent its deter-

mination to stand up to oppose the deteriorating tendency of democracy. Unfortunately, the democratic political elites are not capable of making use of this atmosphere to get these people and their energy on their side.

To be specific, when 30,000 people gathered at the Old Town Square on the anniversary of 17th November in 2018, they were addressed by four philosophers, one theologian and one anti-corruption activist. But not one politician. And these people who are demonstrating do not actually have a political party to which they could attach their hopes; they do not have a politician who would be their leading personality and who would be capable of gathering together various regional political parties and creating from them a united strong movement that would then be capable of defeating the current ruling coalition in regular elections.

The Social Democrats (in government as junior partner to ANO) have pretty much deserted the ranks of democratic parties, and the remaining four democratic parties are evidently incapable of pulling in the same direction on account of the vanity of some individuals in their ranks.

Certainly a major role is being played here by the personal motives of people who want to be on the list of electoral candidates and be re-elected and who do not like the possibility of some stronger candidates than themselves appearing on this list of candidates, because these new candidates could jump over them (through preference votes) and get elected in their place. However, I would say that what is really lacking here is a personality of the type like Václav Havel who would enable these various currents to unite and who would marshal them together. A person who would have sufficient moral credit to ensure that people believe that he or she is not motivated by a desire for self-enrichment or for power, but rather that he or she is concerned purely about democracy and freedom.

The shameful disgrace involving the criminal prosecution of Prime Minister Babiš, as well as having a pro-Russian and pro-Chinese president (Zeman), have damaged the country's reputation. The Czech Republic's prestige in the EU has fallen.

The Czech Republic had an excellent position in the EU still in the 1990s, when Václav Havel was president. In the European Parliament I have experienced on several occasions that politicians have been able to cite Havel's speeches from memory even years afterwards.

We have gradually lost this position primarily because our politicians have not been capable of coming forward with any proposal that would solve European issues. They have actually only been dealing with our internal conflicts and have limited themselves merely to criticizing the EU. When Finance Minister Sobotka wanted to raise taxes, he blamed this entirely on the fact that the EU was forcing us to do this. I then visited the EU commissioner in question and asked him why he did not permit us an exception in the matter of tax, and he said: 'Well, for the simple reason that your government did not want this from me.'

In other words, our politicians have been blaming the EU for things that our politicians themselves are to blame. And after a while a wide section of the public started to believe that the EU is responsible for everything, and today all kinds of nonsense is being repeated about the EU dictating the shape of bananas and the suchlike. People are completely unaware that by our own provincial approach we have actually deprived ourselves of possible influence in Europe. When the refugee wave occurred, then this was a perfect opportunity for our politicians to bash the EU – instead of behaving self-confidently and saying: Very well, this is now an exceptional situation. We are willing to accept, let us say, 10,000 Syrian asylum seekers, but we want the

issues of the EU's external borders and the illegal smuggling of migrants to be resolved. Such an approach would of course have been referred to positively, and we would have been one of the countries that are trying to resolve the problems, and not merely drive them off somewhere else away from us.

Do you think that the values of the First Czechoslovak Republic (1918–38), which in contrast to many other European countries at the time was a democratic country and which provided a home for persecuted Jews and other refugees, still have some influence on the national consciousness in some way?

On the more education sections of society they undoubtedly do, but the wider general public is not interested in this. All that has remained are icons such as Masaryk, possibly Karel Čapek and a few other people who penetrated into this wider consciousness for some reason. Apart from that there also remains some kind of conviction that we are more democratic than the nations around us, which in the most recent period is being shown to be rather an illusion.

On the other hand, after the revolution in 1989 we succeeded in creating a good constitution and a constitutional system that is still now keeping the reins on our crazy political scene. In contrast to our neighbours, this constitution is very rigid and resistant to changes, and thanks to this it is a certain stabilizing element. The constitution restricts the power of politics to penetrate into further and further fields of life and restrict free life.

To create such a system was one of our main political aims after the revolution. This was a question of ensuring that political power was not able to control everything, but rather had a precisely defined playing field. And so today, in spite of the political turbulences, many people are able to live their lives, to engage in business, to build something up, and politics does not actually bother them too much. However, when the general public does not take any interest in politics for a long time, when people are not capable of getting together even at moments of crisis and of trying to remedy the situation, then not even the very best constitution is capable of preventing the danger of the growth of authoritarian tendencies.

What can the Czech Republic offer Europe and the world today?

We have wasted the chance to offer what we could have done after the Velvet Revolution. This was our experience with totalitarian regimes, which experience could and should have led us to reflection about what we had experienced and thereby to us deducing certain findings that could have served us and also other people in the future. We have succeeded neither in reflecting on this experience, nor in passing it on to others.

The essence of democracy is not that you constantly vote about who is going to govern, but rather since antiquity this essence has been the rule of law, which means limiting political power by the law so that it cannot be misused. In totalitarianism power is unlimited with regard to the individual.

Has your character been influenced by the fact that you are a Czech who grew up and lived in the spiritual and cultural environment of this country?

I accept my Czechness with great pride, and the source of this pride is primarily the Czech National Revival in the 19th century. In school this was presented to us in a very distorted form, and I am sorry that I did not devote greater attention to it earlier, because what was achieved by the propagators of the National Revival was amazing and great.

The second thing that I perceive as Czechness is a certain tendency toward practical behaviour. The Czechs have never created any ground-breaking world theory in philosophy, but their contribution has rather been in taking this philosophy seriously and deducing practical consequences from it (Hus, Masaryk, Havel).

And there is one more thing that I would like to mention, and this is actually what I personally find lacking in this tradition. In the 19th century the Czech nation succeeded in reviving itself: it renewed itself culturally, educationally, in terms of business, and even in sport we were present at the founding of the modern Olympic Games. However, at the moment when we had achieved our aim – political independence – our leaders failed to realize that we had been transformed into a political nation, and they did not succeed in breaking away from ethnic points of view. All citizens of the republic are part of the political nation, and this ethnic and linguistic point of view must be put to one side and all emphasis must be placed on equal civic rights. This ethnic and cultural-historical aspect continues to create the content of our national life also in the new situation; none of this is lost. However, ethnic nationalism loses its sense and its continuation destroys democratic politics. And one thing that escapes the attention of our nationalists the most, is the fact that this cultural-historical content is, in the case of all European nations, if not the same, then certainly very similar. We all start out from Greek thought, Roman law, the Jewish-Christian tradition, from Protestantism, from the dispute between Catholics and Protestants, from the inspiration of the Enlightenment, Romanticism, and all this creates the content of our national and cultural history, and in this we are similar to other European nations. Therefore, it is not true that a European nation does not exist. It exists as a cultural-historical unit clearly differentiated from other such entities. A European nation does not exist only from a linguistic point of view. However, in the most recent period even this has been changing, because English as a world lingua franca has actually resolved this problem. Even at a time when the English are leaving the EU.

The standard on the Czech flag bears the inscription Truth Will Be Victorious. But this does not mean God's truth as declared by Jan Hus.

This is a slogan which is connected to a long theological tradition, but the problem here concerns who identifies with this truth as its exponent. The Hussite movement showed that this thought could be misused and could even become a prototype of totalitarianism. In the end a person must remain humble with respect to the truth and be aware that no one of us possesses this truth; that only God possesses it and that we are merely seeking this truth – and this awareness and humility applies for atheists as well. On the other hand, a part of Hus's message is that a truth perceived creates a duty, that this is not merely some kind of intellectual discussion, but that a person is duty bound to act in accordance with this truth, and in the case of the most courageous people to suffer and even lay down one's life for it.

Interview conducted by Olga Sommerová 3. 1. 2019, Prague.

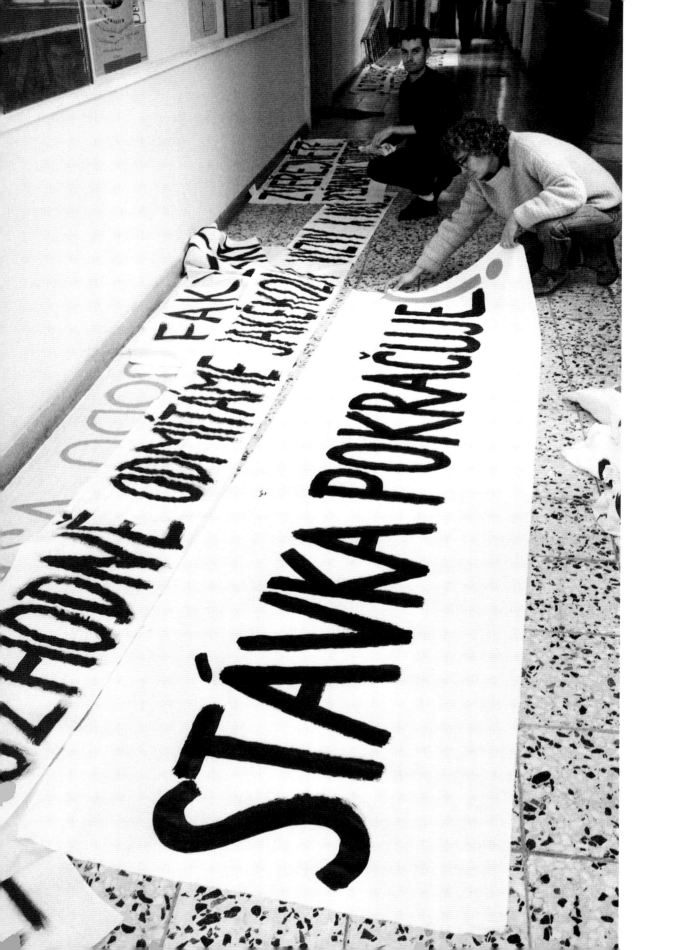

MONIKA MACDONAGH-PAJEROVÁ

For you, what were the important memories which motivated you in 1989?

I was born in the Czech-German borderland and I have always tried to find out what is beyond those borders, what happened in my village before I was born there in the harsh winter of 1966. I remember the story about Mrs. S., a German woman who by marrying her Czech neighbour saved him from being expelled from the Sudetenland region in 1939. He returned the favour in 1945, when he saved her from the expulsion (resettlement of Sudeten Germans from Czechoslovakia). In the end they remained married – that really amazed me.

I gradually learned foreign languages – German, Russian, English, French, Swedish – in order to be able to listen to foreign radio stations and read the newspapers and magazines that I occasionally picked up here and there. I also asked my great-grandmother about the First Republic. At that time my great-grandfather Jan Roth was one of the small number of film cameramen, and so at the end of the 1920s they travelled around the whole of Europe together making films. It sounded like a fairy tale that they were here in France, there in Switzerland, and then somewhere in Britain – and that they could return home without any sanctions.

I also rooted around in the attic for hidden publications from 1968 – occasionally I came across copies of *Reportér* magazine, *MY 68* (*We 68*) or *Literární noviny* (*Literary News*), and so I had the feeling that I had almost personally experienced the Prague Spring and that people like Zdeněk Mlynář, Antonín J. Liehm or Eduard Goldstücker were still living in Czechoslovakia.

My mum, who was a psychologist, had studied with Stáňa (Stanislava), the wife of evangelical pastor Svatopluk Karásek (dissident and singer), and so I also came into contact with the environment of the underground church and the future Charter 77. The apartment of philosopher Jiří Němec and psychologist Dana Němcová at Ječná Street 7 was one of the places where dissidents and the underground used to meet, and where the truth was spoken openly. My dad Otakar and my favourite uncle Alan, both photographers, were active in the milieu of banned rock groups – I admired the musicians Vladimír Mišík and Michal Prokop. Even in the period of the so-called "normalization" in Czechoslovakia these people appeared to be free.

What was the significance of Charter 77? What was your personal experience of meetings with dissidents?

In 1980 when I was 14, I was afraid that they would not let me study at the grammar school, even though I had excellent school results. And it also bothered me that so many of my friends

← Students of the University of Applied Arts (UMPRUM) preparing banners with their demands, 22. 11. 1989. Slogan on banner: 'The Strike Goes On' (ČTK)

and acquaintances of our family were leaving to go into exile. We were closest to the family of Svatopluk Karásek, who lived in a mill not far from our cottage. This was one of the centres of the Chartist movement.

At that time the State Security Service (StB), within the framework of the exceptionally despicable *Cleansing Operation* (*Asanace*), was trying to shift as many dissidents as possible out of the country into exile abroad. Svatopluk Karásek was my idol, a kind of father figure. He improvised his sermons, played guitar and sang beautiful songs around the campfire and thought up things to do for us children. Once he had to go to Prague for an interrogation, and we waited for him nervously at the mill. Sváťa (familiar form of Svatopluk) was taciturn when he came back from Prague, and we asked him to play us something. He picked up his guitar, sat down by the fire, and said sadly: 'Children, a string has broken.' And we said: 'No, no, Sváťa, the string isn't broken. Everything is okay. Play, please.' He repeated patiently: 'No, children, a string is broken in me. They went for me once again, and I know that next time I will start fighting with them. And then they will keep me in prison for a long time... We are going to have to leave as well.'

I remember that the smaller children did not understand entirely, but I cried desperately. For me the world had simply ended, because I said to myself: 'So then, everyone interesting in this country, everyone who does something good for this country, has to leave.'

Apart from the family of Svatopluk Karásek, you also met other communities linked to Charter 77...
One such community was centred around the family of Dana Němcová with her seven children in the famous apartment at Ječná 7; her husband Jiří had been forced into exile. Another was that in the milieu around Věra Jirousová, whose husband Martin Jirous (art historian and poet), known as Magor, was also in prison.

How did you experience your visits to the Němcová family? This was a place where Chartists and the underground used to meet...
Ječná 7 – that was a kind of magical place. I was always afraid when I went there, because police officers in uniforms used to check up on people already on the street in front of the entrance; secret police agents sat at a table on the pavement in front of the apartment and made a list of people entering. When the doors opened, the apartment gave an impression of a massive space into which a lot of people would fit. And everywhere there were shoes, and beloved books. I was always given tea, and I saw that everyone stuck together. With them I did not feel so desperately alone. I had the feeling of a safe harbour, which was an illusory notion, because precisely there it was most dangerous.

Did you experience any concerts of underground groups there?
Apart from Sváťa Karásek, I also really liked Mejla Hlavsa, frontman of the group *Plastic People of the Universe*. He was a fascinatingly mysterious person who declared that he was an Indian (Native American), and he really looked like one. He seemed irresistible to me, handsome and talented, absolutely unshakable. So, when afterwards Mejla once admitted that at every interrogation the StB forced him to sign a paper of cooperation, but that he rather choose to tell us so that we all knew, then as a teenager I could not understand at all how they could have tormented my Indian.

This was similar to when Sváťa Karásek also seemed in some way to become afraid of himself, of what he might do when they tried to provoke him the next time; that he might start to fight

with them and that they would then shut him away in prison for many years. At that time ten people from the Committee for the Defence of the Unjustly Persecuted (VONS) were in custody, of whom six were then sentenced to years in prison. The women of these families and households then had to take over the burden of providing for them in place of the detained men. I carried a photo with small portraits of those ten detained around with me all the time and I thought about them with sadness…

Did your family not consider emigration?

I remember that already when I was 14 I considered whether we should not also leave. In September 1980 our family went to Yugoslavia for the first and last time, and I hoped a little that we would join those who had left within the framework of the Cleansing Operation, and that we would perhaps also go into exile. But my parents could not agree – they argued for two weeks on the Croatian island of Brač. Mum, a psychologist, wanted to leave, and dad, a photographer, wanted to return at any price. He said that he could not exist anywhere else than in the Czech landscape.

And what about you? What did you wish?

I sat alone and lonely on the seashore, and thought about how I could study in some normal country. But I also had horrible dreams that I would never again see that cottage in the borderlands where I was born, or that I would never again walk across Charles Bridge, that I would never again see Prague, that I would never again walk through the Czech countryside, which I love so much.

And it seemed terribly cruel to me, and over and over again I said to myself: why should the people who haven't done anything bad to anyone have to leave, and why should the evil nasty policemen and secret police agents, who persecute these nice agreeable people, remain here. The StB secret police agents even once attacked Zdena Tominová, when she was a spokeswoman of Charter 77. They beat her up in a dark corridor of her house. I was totally shocked by this, because I thought that it was simply not possible that they could beat up such a beautiful educated woman; I thought that they only beat up guys.

But they also cruelly beat up another Charter 77 signatory, Zina Freundová, also a good-looking woman. The fact that she was a woman did not stop them.

They were brutal criminals. Dana Němcová told me that, when she was in prison, she suffered a kidney failure, and they did not give her any medicine; they left her in a cold cell without help. And Dana, mother of seven children, told me that this kidney failure can be worse than childbirth pains! She was writhing in pain there, and they did not help her.

You were not in danger from the StB when you met with the Chartists?

I wanted to make friends with the children of the Chartists; I was constantly attracted to this dissident ghetto. On the one hand I was conscious that this was dangerous, that because of this they could throw me out of school, but on the other hand this community had an irresistible charm. I was fascinated by its power, by its resistance in the face of overwhelming odds. For me they were heroes.

After my teacher Jana Převratská, who organised language courses for people who had to leave, herself escaped to Canada, I started to teach English and German in her place, which in the end came to light. We had an informer amongst us – the pleasant, clever Mr. Křivánek, whom they managed to break. One day I was sitting in school, and from the window I saw two scary black cars draw up in front of my grammar school. Somehow I knew that they were coming for me.

The result was a six-hour interrogation, and the only thing that saved me was that our Russian teacher, the deputy director, Mrs. Martínková, whose husband was a member of the Central Committee of the Communist Party, felt some kind of sympathy for me, because I was an exemplary student who had won for her the Russian language poetry competition Pushkin's Memorial. And so, this hefty person barged into one of the black cars and told them that I was a minor and that therefore she could not let me go to an interrogation on my own. And then she waited six hours for me at that notorious police station in Bartolomějská Street.

I just cried and cried. They wanted to know who was going to these language courses, where we met, how much money I got – I was doing it for free, of course – and mainly where we got our textbooks from. We had them from the Canadian Embassy, but I knew for sure that I could not tell them that.

And did you know the magic formula: 'I refuse to answer'?
Not yet, but I had already seen some arrests of grown-ups. When, for instance, they came for them to that old mill, arrested them and took them away for interrogation, I noticed that you should not speak, that you should not say anything at all. Once we children remained alone at the mill, and I, because I was the oldest, had to take care of the smaller children. The police officers thought nothing of simply leaving us behind in a deserted valley...

Were you later instructed in how to behave during an interrogation by the StB?
At Věra Jirousová's place we usually let the bath water run so that nothing could be heard through the bugging devices, and I learned by heart the *Rules for When Being Interrogated*, which had been prepared by Charter 77.

Later, historians Petr Blažek and Radek Schovánek told me that I was evidently the youngest person on whom an StB file had been established, and this file was immediately classified as a 'signal' file, which meant that I was being monitored with a view to later 'measures'.

And then you returned to school...
Deputy director Martínková called me into her office and told me to be careful not to do things that could get me into problems; that we would not mention it again and that she hoped that this was the end of it and so on... And really, she ensured this!

Later I found in my files that the grammar school director Mikyška, as an StB informer under the code name 'Director', submitted monthly reports about the activities of myself and evidently also other people. In my case this always read: model student, quiet, inconspicuous, evidently in no way socially dangerous, but nevertheless 'prophylactic measures' will do no harm. And these prophylactic measures meant calling in these people for an interrogation from time to time in order to intimidate and frighten them a bit. Which they also did in the case of a few people.

Student magazines *Kavárna* (Academy of Performing Arts in Prague), *Proto* (Journalism Faculty, Charles University) and *Situace* (Arts Faculty, Charles University)

VÁCLAV HAVEL

Pravda a perzekuce

Nerovný zápas o informace

Samizdat edition of *Lidové Noviny* newspaper from January 1989

Another drama happened, when I wanted to get to university. But once again I was lucky with people, and so with the help of Miroslav Jindra, Radoslav Nenadál and Martin Hilský I not only got into the Faculty of Philosophy (Arts) at Charles University, but they also protected me against expulsion, when I started to work on student magazines and attend demonstrations against the communist regime.

Sometimes my professors at the English Department pulled off some amazing things. For instance, with the help of the American Embassy writers William Styron, Philip Roth and John Updike visited. I wrote my master's thesis precisely about American writers of Jewish origin.

For the student magazines *Kavárna* and *Situace*, which were founded by my friends and me, I started to seek out people who had been erased from the national memory, people about whom we students were not supposed to know. For instance, I had an interview with writer and former political prisoner Jiří Mucha (about whom Philip Roth writes in *The Prague Orgy*) and I carried out a series of interviews with artist Jiří Kolář, who was working in exile in Paris. Every week for one whole year he sent me an exquisite collage, on the other side of which there was always an answer to one of my questions. After November 1989 eventually this appeared as a book (*Ven ze stránky! – Out of the Page!*), which was chosen as 'The Most Beautiful Book of 1994' and the prize was awarded to both of us by my admired Pavel Tigrid, who by coincidence was minister of culture at the time!

Personally, I was most interested in the student movement of 1968 at our faculty and the fate of student Jan Palach, who immolated himself in January 1969 in protest against the Russian occupation and the consequent lethargy of the nation. It seemed terrible to me that I was going to the same lecture halls as him, sitting on the same stairs, looking out of the same windows – and yet we were not allowed to know anything about him.

What do you think today about Charter 77? It was the conscience of the nation, which had humiliated itself, bowed down. It was the only opposition to the communist regime.
The incredible community of people around Charter 77 confirmed to me my private theory that all great historic movements or events are driven by 20, or at most 30, people – the founders. And other people then attach themselves to this core... Because, when we speak about the Czech National Revival in the 19th century, the foundation of Czechoslovakia, the resistance during World War Two, the resistance to the communist regime in the 1950s, or the Prague Spring in 1968, then it was always a handful of people who fought for something even with the knowledge that they might very well not succeed! That this was possibly a lost battle, but they went into it anyway in order to stand up to injustice. They simply could not do otherwise...

In the milieu of the Chartists I perceived an admirable sense of reconciliation with the fact that they were not able to perform their real professions: the men did manual work in furnace plants, washed shop windows or performed water measurements, while the women worked as cleaners. People with an education as diplomats, teachers, philosophers, historians or journalists toiled manually all day long so that they could then write in the evenings! They knew that they would be followed and wiretapped by the State Security (StB), that they would have to regularly undergo interrogations, that they might well be sent to prison for a few years along with ordinary criminals, that their houses would be constantly searched and that they children would not be able to attend decent schools or universities. It was even possible that they would have their passports and driving licences taken away and they would never be allowed to travel abroad in case they might want to stay there for good. But nevertheless all these people said: 'No, we are not budging from here. This is our home. Let them (the Communists) go!'

I think it was terribly important for us young people that these dissidents maintained on our behalf a consciousness of the core of our existence, from which we could not allow ourselves to retreat internally, which could not be allowed to be forgotten. For instance, by a complicated route Václav Havel succeeded in getting Prokop Drtina's manuscript *Československo, můj osud* (*Czechoslovakia, My Fate* – book of memoirs by democratic politician Prokop Drtina about events leading up to the communist putsch in 1948) to the West. When I read this in a samizdat publication, I totally gobbled up the pages, because I finally found out about the Czechoslovak government-in-exile in London during World War Two, and about how it had been possible to achieve so much during those 20 years (1918–1938), from which we then profited for long decades. Poor Václav Havel went to prison for this manuscript, as soon as Pavel Tigrid published it in his magazine *Svědectví* (*Testimony*) in Paris.

They were real public intellectuals in the best sense of the word (today technologists of power like Miloš Zeman, Václav Klaus or Andrej Babiš laugh at them), who were conscious that their main task was to maintain common sense and a clear conscience, and not to embezzle, betray or forget. And to maintain a ray of hope, even if only a tiny one, just as the hunters of mammoths kept a small flame going and carried it from one cave to another.

These people knew very well that this was a battle of life and death, and that it was going to last a long time. When I was young, I sincerely thought that we were going to spend our whole lives in the communist regime. We young people did not believe what my grandma or my great-grandmother recounted: that the regime would fall before the next plum crop and that this system could not possibly survive long-term.

We, university students in the 1980s, thought that the Communists were going to rule for ever, and that the West had reconciled itself with the fact that Europe was divided into East and West. We talked about the fact that we must maintain at least some kind of awareness about what the Czech nation had been precisely during the First Republic and during those eight months from January to August 1968, and what it still was during those few successful operations by Charter 77, when they succeeded in sending some document about their activities or some samizdat literature to London or Paris.

We also always rejoiced when someone succeeded in getting something through those barbed-wire borders to radio stations the Voice of America and Radio Free Europe. We listened to them every evening and the voices of people like Lída Rakušanová, Milan Schulz or Ivan Medek, the Voice of America correspondent in Vienna, were totally legendary figures for us. I had no idea what they looked like, but behind those voices I envisaged incredible heroes, and so when during November 1989 I saw them with my own eyes, I was pleasantly surprised that they were normal people from flesh and blood. For me these people had heroic proportions and I could not get my head around the fact that, for instance, singer and poet Karel Kryl was so small or that singer and writer Jaroslav Hutka was so naturally cheerful and modest too.

Charter 77 also issued various so-called communications. Over a period of 13 years there were 1,200 of these.

This was incredible, in view of the restricted possibilities. As I already said, they worked in furnace plants or as cleaners and they had absolutely no access to important information from the Czech Press Agency, from the Academy of Sciences, the universities or the research institutes. And nevertheless they were capable of putting together sensible opinions on the state of human rights, church life, or the environment. It was important for us that they were interested in young people: they were the first to say that the regime's greatest crime was that it did not allow young people to study who had the ability to study and wanted to study. To this day I am convinced that a good education is the most important thing in the life of a young person.

They also drove out excellent pedagogues. I know this from the Film Faculty...

Yes, opportunists quickly sensed an opportunity and quite literally banished their colleagues from the building. So, we students at the Philosophy Faculty were not allowed to mention Jan Palach, Luboš Holeček, Václav Černý, Růžena Vacková, or Eduard Goldstücker, let alone T. G. Masaryk. Not even the smallest mention of the most significant people of our faculty was permitted. We had to pretend that these people had never been in the building, that they had not written anything, that they had not even existed, that we were actually starting to study completely from scratch, from nothing.

But you had philosophy. You had Marxism-Leninism.

That was an absolute horror. When a person signed up for Philosophy, English and Scandinavian Studies, like myself, then you were obliged to attend the terribly debilitating seminars

on the 'scientific' theories of Marxism-Leninism and the history of the international worker's movement. The only consolation was that in the 1980s this had been completely formalized, and the teachers themselves made a truly demented impression.

I have heard that at the end of the 1980s students started to rebel against the teaching of Marxism.
Luckily, after 1985 the phenomenon of Mikhail Gorbachev in the Soviet Union started to make itself felt here as well.

From the beginning he interested me. I sought out information about him and ascertained that he had studied in Moscow with Zdeněk Mlynář, and so he certainly knew Mlynář's true book about the occupation of Czechoslovakia (*Nightfrost in Prague*). Allegedly he said privately that his reform of the Soviet Union could have come 20 years earlier, if Leonid Brezhnev had not sent in tanks to crush the Prague Spring. I liked that!

At the faculty we had an information noticeboard, which later turned into the magazine *Situace*. This was successful among our fellow students and brought us great satisfaction, but also caused constant battles with Dean Vaněk and comrade Veselý, the chairman of the university Communist Party organization. One or the other physically tore down this noticeboard a few times and demonstratively tore it up into pieces. In the end they locked it up in the glass display cabinets in the cellar.

Apparently, you put articles from the Russian press about perestroika on this noticeboard.
We snatched at every hope, and so we translated complicated articles about 'glasnost' and 'perestroika'. I admit that we were absolutely enthused when Mikhail Gorbachev came to Prague. Just imagine, we voluntarily welcomed him along Lenin Avenue, today Europe Avenue (Evropská třída), when he travelled from the airport to the centre of Prague!

But then you were disappointed in him. He did not say anything about the occupation in 1968.
We were waiting for him, but the police did not allow us to discuss with him. He did not even respond to our enthusiastic chanting 'Long Live Gorbachev!'. He did not react at all. We were disappointed, but today I think that his visit to Prague, where he did not express himself at all, was not superfluous.

I would say that, in view of the similarity between Czech and Russian, when we chanted at him in Czech 'Long Live Perestroika, Long Live Glasnost, Long Live Gorbachev!', he must have understood well. He also certainly saw the crowds of people all along the entire route to the Soviet Cultural Institute in Rytířská Street. He walked with a smile down Na Příkopě Boulevard past the waiting crowds and, even though at that moment he did not express himself in any way, something of that atmosphere certainly remained in his mind.

This only became apparent after some time. Because later in 1989, when the hard-core Czech Communists – those traitors who called in Russian tanks to crush the Prague Spring – were desperately waiting for Gorbachev to help them, he simply did not give a damn about them.

The communist regime was totally riddled with lies. But when you do not live in truth and with truth, life is worth nothing.
It completely loses sense. When a person lives in an environment which is based on a lie, when careerists who are skilled in lying get ahead, and the rest allow this to happen, then the situation is really bad. In such a situation every voice that says: 'This is good, and this is bad. This is the truth and this is a lie!' has an enormous significance.

True words have such incredible power that they are really capable of undermining even a mendacious regime.

The confusion about values in our current-day world is about this, I think, because so many words appear on social networks in an unreal parallel space – some true, but also many untrue, literally hateful, intentionally hurtful – that a person who does not have the relevant education, or who does not devote enough time to checking information, gets completely lost in all this.

In 1988 demonstrations started on the occasions of important anniversaries for Czechoslovakia: on 28th October the 70th anniversary of the foundation of the republic, on 21st August 20 years after the Soviet occupation. You went to these demonstrations.
For me the demonstration on 28th October 1988 was a breakthrough. In the evening I wrote in my diary:

'Friday!!! BIG DAY – demonstration on Wenceslas Square.
The most important day for a long, long time. Finally, something makes SENSE! This community of people – and I was really me myself!'

Meanwhile it was a shocking experience, and my original idea that I would go and demonstrate with my young child Emma in a pram shows that, in spite of everything, I was still quite unprepared for a conflict with power. Luckily, I left my little girl at home with an auntie, and my fellow student Jana Svatošová and I set out from the faculty for the demonstration.

Encouraged by the number of people on the Old Town Square we cheerfully set out for Wenceslas Square and there, at the statue of St. Wenceslas, there was an intoxicating common joy, such as I had never felt before. The chant 'Freedom, Freedom!', the clapping in rhythm, the singing of the national anthem, calling out to the police officers 'Long Live the Republic!', the relaxed joking and laughter.

Then all of a sudden there was a dramatic change. Water cannons and armoured personnel carriers rolled into positions all around the square. Police officers with truncheons and dogs jumped out. It was the dogs that I was most afraid of... They stormed frenziedly towards us and lashed out in all directions. Jana and I were squashed in the middle of the crowd. There was terrible confusion all around and people calling for help. We ended up in one of the passageways, and more and more people were falling in on us, as they were driven out of the square by water cannons. We were pressed up against a glass shopfront, police officers and dogs behind us, and in front of us a horror of possible broken glass. We were all totally beside ourselves; there was an indescribable panic, and I had the feeling that we were never going to get out of there again. I had no idea that one year later I was going to feel just as terrified when caught in a trap at Národní třída (National Boulevard), and that this would also be a Friday!

In tears we made our way to the Hotel Evropa and someone opened up for us out of sympathy. People in wet clothes were sitting around there with their teeth chattering out of shock. We passed around hot tea, pressed up against the hot radiators in a state of fright, but paradoxically this experience brought us closer to people whom up until then we had not known.

This was the greatest mistake of the Communists – the more they forced us into a corner, the more outraged we became: for instance, two pleasant and seemingly obedient students of the Philosophy Faculty. For the first time in my life I had the feeling that in this crushed, beaten crowd we had a common purpose, that we understood each other without words, and that we all hoped for the same thing.

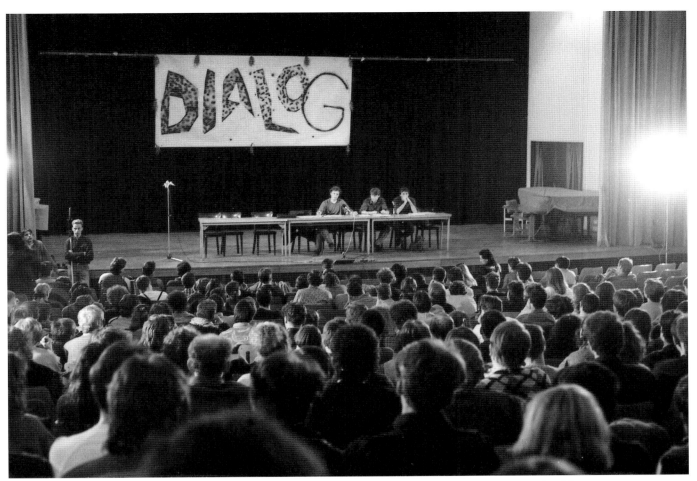

Dialogue – Public discussion forum of Academy of Performing Arts (AMU) in Prague at City Library, 3. 4. 1989. The empty chairs on the podium were intended for representatives of the Communist Party and the government, who did not turn up. (Milan Podobský – known as Fefík)

Society only started to become activated during Palach Week in January 1989.
Today it seems unbelievable to me that inconspicuous student Jan Palach, who immolated himself 20 years earlier in order to wake up the nation from its lethargy after the Russian occupation, was all of a sudden *alive* for us. In some way his torch lit up again; people met at Wenceslas Square in order to protest against the regime, which used all available means: police officers with truncheons and dogs, secret police agents in civilian clothing, water cannons and armoured personnel carriers, Anton armoured vehicles for rounding up people and arresting them.

I sought out everything I could find about Palach; I found a transcript of a song by Bohdan Mikolášek, which included the words 'a living person died so that the dead remained to live...'. It had a massive effect on me that this person who was long ago dead was more alive than us, who were wandering about the faculty and who mainly wanted to complete our studies and find a nice job and a calm family life.

For the first time it occurred to me that possibly the most important thing was not whether I completed my studies, or whether I learned those five languages of mine, or whether I was going

NĚKOLIK VĚT

První měsíce roku 1989 znovu a jasně ukázaly, že i když se současné československé vedení velmi často zaklíná slovy "přestavba" a "demokratizace", ve skutečnosti se dost zoufale vzpírá všemu, co demokracii vytváří nebo co ji alespoň vzdáleně připomíná. Petice a iniciativy občanů, které samo neorganizovalo, odmítá jako "nátlakové akce"; odlišné politické názory odsuzuje jako "antisocialistické" a "nepřátelské"; pokojná lidová shromáždění rozhání; do přípravy nových zákonů nedovoluje veřejnosti mluvit.

Tytéž měsíce však zároveň ukázaly, že občanská veřejnost se už vymaňuje z letargie a že stále více lidí má odvahu veřejně projevit svou touhu po společenských změnách.

Pohyb ve společnosti se tak začíná stále povážlivěji srážet s nehybností moci, roste společenské napětí a začíná hrozit nebezpečí otevřené krize.

Takovou krizi si nikdo z nás nepřeje.

Proto vyzýváme vedení naší země, aby pochopilo, že nadešel čas ke skutečným a důkladným systémovým změnám a že tyto změny jsou možné a mohou mít úspěch jen tehdy, bude-li jim předcházet vskutku svobodná a demokratická diskuse. Prvním krokem k jakýmkoli smysluplným změnám, novou ústavou počínaje a ekonomickou reformou konče, musí být tedy zásadní změna společenského klimatu v naší zemi, do kterého se musí vrátit duch svobody, důvěry, tolerance a plurality.

Podle našeho názoru je k tomu třeba:

1/ Aby byli okamžitě propuštěni všichni političtí vězňové.

2/ Aby přestala být omezována svoboda shromažďovací.

3/ Aby přestaly být kriminalizovány a pronásledovány různé nezávislé iniciativy a začly být konečně chápány i vládou jako to, čím v očích veřejnosti už dávno jsou, totiž jako přirozená součást veřejného života a legitimní výraz jeho různotvárnosti. Zároveň by neměly být kladeny překážky vznikání nových občanských hnutí, včetně nezávislých odborů, svazů a spolků.

4/ Aby byly sdělovací prostředky i veškerá kulturní činnost zbaveny všech forem politické manipulace a předběžné i následné skryté cenzury a otevřeny svobodné výměně názorů a aby byly legalizovány sdělovací prostředky, působící dosud nezávisle na oficiálních strukturách.

5/ Aby byly respektovány oprávněné požadavky všech věřících občanů.

6/ Aby byly všechny chystané i uskutečňované projekty, které mají natrvalo změnit životní prostředí v naší zemi a předurčit tak život budoucích generací, neodkladně předloženy k všestrannému posouzení odborníkům i veřejnosti.

7/ Aby byla zahájena svobodná diskuse nejen o padesátých letech, ale i o Pražském jaru, invazi pěti států Varšavské smlouvy a následné "normalizaci". Je smutné, že zatímco v některých zemích, jejichž armády tehdy do československého vývoje zasáhly, se dnes už o tomto tématu začíná věcně diskutovat, u nás je stále ještě velké tabu, a to jen proto, aby nemuseli odstoupit ti lidé z politického a státního vedení, kteří jsou odpovědni za dvacetileté upadání všech oblastí společenského života u nás.

Každý, kdo souhlasí s tímto stanoviskem, může je podpořit svým podpisem.

Vládu vyzýváme, aby s ním nenaložila tak, jak je dosud zvyklá s nepohodlnými názory nakládat. Zasadila by tím osudnou ránu nadějím, jimiž jsme vedeni, totiž nadějím na skutečný společenský dialog jako jediné možné východisko ze slepé uličky, v níž se dnes Československo nalézá.

Several Sentences: text of the petition that expressed society's dissatisfaction with the political situation in spring 1989

to be a nice good teacher, such as I dreamed of being. This was a big shock. In comparison to Palach I felt terribly cowardly, desperately average. And – I was ashamed of myself.

How did you experience Palach Week? It was 20 years after his act, on 16th January 1989, that Charter 77 placed flowers and a ribbon at the memorial to St. Wenceslas, and this provoked a brutal response from the police officers.

I was split. On the one hand, I was terribly afraid, because I had my little Emma, and I was in danger of being thrown out of university. But at the same time I was enthusiastic, because all of a sudden, for a moment, there were a lot of us. This was probably a kind of breakthrough. I became aware that everything that I had done up to that point – teaching languages for the Chartists, writing articles for the student newspapers, going to unauthorized concerts and demonstrations – none of this amounted to anything in comparison with what Palach did or what the people from Charter 77 were doing. And that I simply must go to that square, even at the risk that they would kick me out of university, which was something that up until that point was inconceivable for me. All of a sudden I knew that one time or another we must *all* gather at one place.

During the period of Nazi occupation the students protested in 1939, under communism in 1948 and 1968, and you students were the trigger that caused the revolution in 1989, which has come to be known as the Velvet Revolution.

The fact that we students must do something together was clear to us at the latest from the impression made on us during Palach Week. Everything happened all at once. Some fellow

/61

students were threatened with expulsion from university for distributing leaflets; we feverishly produced our noticeboard newspapers and *Situace* magazine; we fought with the faculty leadership and with the party committee; and we found out that similar things were also happening at other faculties.

Principally in defence against the new press law, which would have annihilated us, Martin Mejstřík (*Kavárna* magazine), Pavel Žáček (*Proto!* magazine) Tomáš Drábek (the medical students' magazine *Emko*), myself and some other colleagues decided to found a discussion club in a cellar on the Old Town Square. We called it the Students Press and Information Centre (STIS).

There we divided up materials between individual student magazines and we exchanged information about events, concerts and exhibitions. We made contact with some people from really illegal structures, such as the Independent Peace Association (NMS – Jana Petrová, Hana Marvanová, Tomáš Dvořák), the Society for a More Cheerful Present and the Czech Children (Petr Placák). We invited to our meetings lawyers and more experienced people from the samizdat version of *Lidove noviny* newspaper. At STIS we gathered signatures for the Several Sentences petition (created by Václav Havel, Saša Vondra, Stanislav Devátý and Jiří Křižan) and indignantly discussed how the Chinese Communist Party, after a few weeks of negotiations, overnight dispersed the student protests on Tienanmen Square (the square of Peace!) in Beijing. A feeling of fear that something similar might happen here remained inside me...

We also invited to STIS children from Charter 77 families like Marek Benda, Jiří Dienstbier and Ondřej Zach, who were involved in the conspiratorial student community STUHA. We agreed that we needed not only the same few hundred people to turn up at the square to demonstrate, but tens of thousands of people who would not be afraid to come – just as the evangelical church had succeeded in doing in East Germany at the so-called peace marches in Dresden, Leipzig and Halle.

Martin Mejstřík and I then went up to Leipzig University to visit some friends of mine and we received the advice that we should make use of some anniversary in order to involve our parents and grandparents. It had also occurred to Václav Benda and our colleagues from STUHA that the 50th anniversary of the funeral of student Jan Opletal, shot dead by the Nazis on 28th October 1939, was approaching. Together we succeeded in getting a permit for a memorial event, and it was this event that became the trigger for the Velvet Revolution.

When on Friday 17th November at 4 p.m. we arrived at Albertov, the area in front of the Medical Faculty was absolutely packed with people. There were flags everywhere, banners, flowers, candles. I had never seen so many people before!

And the crowd of people was already chanting slogans: 'Human Rights', 'Freedom, Freedom', 'Jan Palach – Jan Opletal', 'the Czechoslovak Communist Party Lies', 'Forty Years Is Enough', 'Students of All Faculties Unite!'

I started my carefully prepared speech about dialogue:

'Friends! In the recent period the word dialogue has taken on a truly magical significance. Recently the hopes of a wide range of layers of our society, primarily of us, young people, have turned to this forgotten word. However, on this important day let us ask: How many opportunities do we, university students, have to participate in really free, democratic dialogue?'

We organizers kept on reminding each other: 'We must stick to the conditions of the permitted march'. And so, we conducted the crowd up the hill to Vyšehrad, where we laid wreathes and

Vezmi si s sebou květinu

17. listopadu si připomeneme 50. výročí slavných i tragických
událostí, k nimž došlo v souvislosti s pohřbem studenta lékařské
fakulty UK Jana Opletala, smrtelně zraněného při proti-
okupantských demonstracích 28. října 1939. Zdánlivou tečku za
tímto novým protinacistickým vystoupením znamenala okamžitá bru-
tální persekuce: 9 studentských předáků bylo popraveno, na 1500
studentů odvlečeno do koncentračních táborů a české vysoké školy
uzavřeny. Současně se však ve světě zvedla vlna rozhořčení, která
vbrzku vedla k ustavení právě 17. listopadu za Mezinárodní den
studentstva.

Nechceme jen pietně vzpomínat tehdejších tragických událostí,
ale chceme se aktivně přihlásit k ideálům svobody a pravdy, za něž
jejich účastníci obětovali své životy. Neboť i dnes jsou tyto
ideály vážně ohroženy a my se nechceme dát zahanbit svými vysoko-
školskými kolegy, kteří za ně před 50. léty odvážně vystoupili.

Proto dne 17. listopadu po 16 hodině půjdeme od Patologického
ústavu na Albertově, kde vyšel pohřeb Jana Opletala, přes Karlovo
náměstí, Štěpánskou ulicí do Opletalovy ulice, kde v parku před
Hlavním nádražím položením květin pietní akt ukončíme.

Leaflet 'Bring a Flower With You' inviting people to the student assembly on 17th November 1989, which commemorated 50th anniversary of closure of Czech universities by the occupying Nazis

candles at the grave of poet K. H. Mácha. It was already dark; we sang the national anthem; there was a mystical atmosphere in the graveyard.

Then of course it did not even occur to us to disperse in accordance with the permit and we spontaneously started to stream down from Vyšehrad to the riverside… Finally, there were tens of thousands of us!

So, we fell for the illusion that the regime had already actually fallen. We were in a state of euphoria, which cannot be rationally explained, because we were still in an occupied Czechoslovakia and those Russian tanks and occupying troops were still here.

We walked along the riverside, flags were waving, candles were burning, we were singing folk songs and the national anthem and the spiritual *Jednou budem dál* (We Shall Overcome) and we were in a great mood. When we got to the corner with National Boulevard (Národní třída), some of the people said: 'And what if we marched off toward Prague Castle right now, just like the students in 1948 marched up to see President Beneš?' And we said: 'No, we are going straight to Wenceslas Square!', because we were now so very sure of ourselves. The entire procession turned around toward National Boulevard and we had absolutely no idea that they were luring us into a trap.

At one moment I went to have a look at the back rows, and I saw that behind us there was a completely empty National Boulevard. They had simply cut us off from that massive procession. And waiting in front of us were police officers in white helmets with truncheons, members of the special anti-terrorist units were abseiling down from the roofs, and behind them armoured personnel carriers had formed several rows so that we could not get any further.

Just imagine how exhausted we were. We had marched around from four in the afternoon until nine in the evening, and then stood, sat, waited on the ground at National Boulevard. It was already completely dark, we were hungry, we were thirsty, we were terribly cold, a number of people needed to go to the toilet and now there was nowhere to go, because all the side streets were roped off, and all the cafés and shops were all of a sudden closed. Behind us armoured personnel carriers with plough blades, and in front of us plexus shields, policemen with truncheons, and calls to disperse being broadcast through loudspeakers!

For many people it was a shock. And I must say that even we who had already experienced a few demonstrations before suddenly felt that this time it was different. We cried out superfluously: 'Our hands are bare!'

At one moment they evidently received a command and they started their intervention – a terrible confusion arose, desperate cries, painful wailing, and that entire crowd started to move backwards, because they were pressing us into a corner under the arcades in Mikulandská Street. At the last moment someone pulled me and some other people into a passageway on the left-hand side and into a dark stairway. There we waited in terrible horror until everything was over. I tore to pieces the 'Bring A Flower with You' leaflets and the remnants of my speech from Albertov. I was shaking with cold; my head was buzzing.

I must say that it was the worst moment of my life. All around torn clothes, discarded shoes, traces of blood; in some places candles were already burning. There was an entirely funereal atmosphere. In the arcades there were really some covered bodies of people lying there. It was a landscape after a battle.

(Later we found out, through friendly doctors such as Martin Bojar, that 568 people, mostly young people, had come forward who had suffered serious health and psychological consequences from that massacre, which was the biggest since 1969.)

I was blundering around there totally in shock when I bumped into Pavel Dobrovský from FAMU, who whispered to me: 'Perhaps there were even some deaths.'

My head started spinning and I had the feeling that I would not get out of there. I had dead people on my conscience. After all it was me for STIS and Marek Benda for STUHA who had gone around the faculties; it was me who had tried to persuade my fellow students that they must come and that this time they did not have to be afraid!

At 10 p.m. I was supposed to meet with the other organizers of the march in the café at the Municipal House. When I rushed in, I was the last one to arrive. Martin Mejstřík, Pavel Lagner, medical students Vašek Sinevič and Tomáš Drábek, Pavel Žáček, and all the others were already there, and all of them were in the same state of shock.

'Guys, what are we going to do?'

Someone mumbled: 'We are going to have to go on strike, an occupation strike. We no longer have anything to lose.'

And I said: 'They will pull us out by our legs first.'

And someone else: 'They cannot get away with that. It is academic ground!' As if that should matter to the communist power.

We dredged up all our strength, and during that Saturday and Sunday we really organized strike committees according to individual faculties. And so, on Monday morning an occupation strike started at most faculties in Prague.

During that decisive weekend it interestingly became apparent that the most reliable people were those who had already known one another for two or three years before. Students who had worked on the *Kavárna* student magazine at AMU or the *Situace* magazine at the Philosophy Faculty or *Proto!* at the Journalism Faculty or *Emko* at the Medical Faculty, or they were students who knew one another from film clubs, from rock groups, from attempts at student self-government, from church circles or because they went to demonstrations together.

In order to ensure that we did not disappear overnight without trace like the students five months ago in China, we needed to make ourselves known. We needed people to know our faces and to know about us; that we were not some terrorists. We wanted to write a text outlining our program for foreign journalists, who were beginning to arrive in Prague, but mainly we needed to explain to students at all faculties on Monday what had happened on Friday, why we were going on strike and what our demands were.

In the night from Sunday to Monday, after a discussion lasting many hours, we formulated our first

'Declaration of University Students'
1. We demand the establishment of an independent investigative commission on the intervention at National Boulevard on 17 November 1989.
2. The immediate punishment of all persons responsible for ordering the Prague massacre. We also demand information about the state of health of those wounded.
3. We call on the employees of all media outlets not to participate in the spreading of false information about current events in Czechoslovakia.
4. The immediate release of all political prisoners and the halting of criminal prosecutions of the unjustly accused.
5. We demand the initiation of effective dialogue with the whole of society without exceptions.
6. We demand the legalization of *Lidové noviny* newspaper and all independent printed materials.

7. We demand the right of assembly, which is guaranteed in the Constitution.
8. We appeal to university pedagogues and other citizens with a request for maximum support.
9. We demand the publication of this Declaration and also that the public be provided with truthful information about the ongoing student strike.
10. We appeal to all citizens who are not indifferent about the state of affairs in our state to express their will by a general strike on 27th November from 12.00 until 14.00.

Monday, 20th November 1989, students of Prague universities.

Without knowing it, we had ten demands, just like the students in the strike in November 1968 and some of them were the same – the abolition of censorship, freedom of assembly, dialogue involving the whole of society.

At the Strike Coordination Committee in Řetězová Street from the very first day we received warnings that Prague was surrounded, that 35,000 armed men were waiting for an order – special purposes units, the People's Militias, Public Security, the State Security, the entire army, were reportedly at the ready. Then this information became more specific: apparently on Wednesday afternoon there was supposed to be an occupation of Prague, the universities would be cleared out, and control would be taken over Czech Television and Czech Radio.

Evidently a battle was taking place in the Central Committee of the Communist Party of Czechoslovakia. The hawks were waiting in vain for help from Moscow; they were under pressure from the ever bigger demonstrations. Some top foreign journalists, such as Timothy Garton Ash, Edward Lucas or Misha Glenny, were already here in Prague and it was clear that the whole world was watching events in Berlin and Prague. Gradually the regional towns and cities also joined in. In the end the Communists decided not to intervene militarily and they started to negotiate with Civic Forum, of which the Student Movement was a part.

Today we now know with certainty that there was really a risk of a military intervention and a Chinese scenario, and I admit that I was very afraid. As a result of that black Friday, of that experience on National Boulevard when I really felt a fear of death. In my whole body I felt the danger that I would no longer take care of my daughter Emma, that I would never see my sister Káťa again, and that there would never be anything again... Sometimes it flashed through my mind that I was only 23 years old and that it was therefore unjust, such a short life.

The occupation strike was exhausting; it lasted several weeks. As representatives of individual faculties, we met daily at the Disk theatre, where we formed a strategy. From here students travelled out to the regions, and we often had to vote on difficult steps. One day a discussion started up about whom university students could envisage as Czechoslovak president. Only a few students knew Václav Havel; names such as Alexander Dubček or Valtr Komárek were mentioned.

I wasn't totally happy with this. So, I ran down to the Laterna Magika (Magic Lantern) theatre, which served as the headquarters of Civic Forum and literally dragged Václav Havel down to the Disk Theatre so that he could seek the favour of the young men and women who did not know him, and therefore did not want him. He was not very keen on doing this, but pretty quickly he won the hearts of his listeners. In the end we voted in favour of Václav Havel as the students' candidate and we helped him in his first election campaign.

Are you happy that you experienced all this?
Yes, I am very happy, but I also feel a little bit guilty that our generation did not have the misfortune that my student colleagues had in 1968 and 1969. They either went into exile or went to

prison. In 1939 and 1948 students also mostly ended up in a concentration camp or in prison, or at the very least they were thrown out of the faculty. We were the most fortunate student generation of the 20ᵗʰ century.

After the Velvet Revolution for many years we thought that democracy and freedom could not be threatened. And all of a sudden, here in the Czech Republic for at least five years, we see that a democratic system need not necessarily last for ever.

It is true that, after a series of non-violent revolutions in Poland, Hungary, Czechoslovakia and also East Germany at the end of 1989, we really thought that in the end good triumphs over evil and that what had been formulated by Francis Fukuyama – that is, the 'end of history' – had really happened: that the Cold War had ended, that liberal democracy had been victorious over communism and that everything was now in order.

Therefore, for those of us from Civic Forum's foreign committee who joined the Foreign Ministry when Jiří Dienstbier, a spokesman for Charter 77, became minister, three main tasks were clear. Firstly, to get the Russian troops out of the country, which was not at all easy. Secondly, to join NATO as soon as possible, so that we would finally, for the first time in our history, have a security assurance. And the third thing, for me the most personal matter, was to join the European Union as a cultural sphere of civilization to which we wanted to return from the very first days of the revolution. After all, already at the student demonstration at Albertov one of the slogans was 'Back to Europe!'.

And we thought that democracy is eternal. But it is not. It must be defended every day, and we have not done this.

I think that the current crisis of values and democracy has been caused by the fact that for a long time Europe has not experienced any war. People who remembered the First World War and the Second World War, which arose as a consequence of the first one, these people in the West knew very well that it was necessary to stick together, that it was going to be necessary to build bridges, first of all between France and Germany, and that it was necessary gradually to unify Europe. To ensure that the big no longer made decisions about the small, but that everyone should sit down at one table as equal partners.

Why are populists and totalitarians like Zeman and Babiš winning here? What has happened to us?

What has happened to us, unfortunately, is what has happened to others. It is no accident that in Poland Jaroslaw Kaczyński is ruling, in Hungary the authoritarian Viktor Orbán, and in Slovakia until recently they had to deal with Vladimír Mečiar and Robert Fico. It seems that the whole of East and Central Europe has still not come to terms with the inheritance of Nazi and Communist totalitarianism. All of this was shut up here as though in a fridge, actually from the year 1938.

Now you open the fridge and all those frozen skeletons fall out on you, all those unprocessed traumas: Munich and the occupation of Czechoslovakia by the Nazis, the communist putsch and the defeat of the democrats, the brutal 1950s, the hopes of the Prague Spring and yet another occupation of Czechoslovakia, the period of so-called normalization, and finally the Velvet Revolution, but also unfortunately a clear line drawn under the crimes of communism on account of fears about violence.

That is why we are now conducting tough debates with people who, for one thing, claim that there was no totalitarian regime here before 1989 and, for another, try to turn people's dissat-

isfaction against 'intellectual elites'. These people are skilfully misusing the fact that after 1989 some politicians promised things that were not realistic. At Civic Forum originally we did not have any economists. And so we quite happily invited Václav Klaus and other so-called experts from the Prognostic Institute, which was actually an agency of the KGB, and these people outlined to us a vision which was Marxism turned upside down. They said: 'People are not interested in some ideals. We know something about this. What is important is the basis: that people quickly have a salary of 20,000 crowns a month (approx. ten times as much as the average wage at that time), that everyone has a nice house and two cars like in West Germany.' Prime Minister Václav Klaus, later the president of the republic, set off a round of populism, issued privatization coupon books with his own 'signature' and already in 1992 easily defeated Civic Forum.

For me this was the beginning of the end of the ethos of the Velvet Revolution. Within the framework of that wild privatization an enormous amount of embezzlement also took place. The lights were turned out for a moment and the national wealth was pillaged. Václav Klaus is the author of the statement that he does not know any such thing as dirty money. And so, people saw injustice all around them everywhere and they ascertained that it was not always decent goodhearted people who were making a profit from the Velvet Revolution, but also that predators and unscrupulous sharks were also often making a profit out of it...

Former communist officials and agents and secret police collaborators.
Yes, they had the best access to information and to funds, and so they had a head start in the big national robbery. The banks gave them enormous loans, and they presented their privatization projects, which they themselves most probably did not even for one minute believe that they would actually implement. Ordinary people often had the feeling of an enormous injustice – that the winners were not those who had risked prison, but those who had held up the communist regime.

And it was evidently there that the moral dissolution of society started. The result was that, first of all we had the immoral 'opposition agreement' between the opposition of Václav Klaus and the government of Miloš Zeman (1998–2002), and now with the support of one-third of the electorate Andrej Babiš has become prime minister – one of those people who profited most from the 'wild privatization', a proven fraudster, a former Communist and agent of the StB secret police. This is a situation which absolutely nothing can excuse.

Those of us who experienced the 20 years after the Russian occupation, called normalization, now have the feeling that we find ourselves in a phase of neo-normalization.
We are returning to the fact that our country was twice occupied in the 20th century, first by Germany and then by Russia. Germany is now democratic. It does not threaten us; on the contrary, for us today it is a political guarantee, because for a long time it has engaged in the process of coming to terms with its past. What now threatens us is a great Russia. Vladimir Putin has one aim – to dismantle West European society, to break up the EU. And the Czech Republic, on account of its geographical position, is an ideal foreground.

The Russians need to weaken Europe, because it will then be easier for them to control it. The imperialist spirit of Russia is eternal, and we have tragic experience with this. And not only us, but also the Ukrainians, the Poles, the Baltic states, the Hungarians...

Western Europe is naïve in the matter of Russia. I served as cultural attaché at our embassy in Paris and already in the case of the French I ran into an idealized notion of the Russian soul. Then I worked for the Cultural Committee at the Council of Europe in Strasbourg and I saw that the Germans or the British, without our experience, also view Russia quite romantically.

It can be said that I was battling against the rise of Russian imperialism for four years in Paris and for another four years in Strasbourg. I never believed the theory that we will cultivate the Russians by allowing them to look into European structures as much as possible, by giving them as much information as possible about our institutions and our projects. I have always rather been afraid of them, because the period of Mikhail Gorbachev lasted a truly short time, and – as has been said – democracy has never functioned in Russia before.

When the Council of Europe started to seriously negotiate with Russia, this made me feel physically sick. I listened with amazement to naïve ideas that, if we accept Russia as a regular member, it will no longer carry out secret torture in prisons, it will respect freedom of speech and give space to the democratic opposition. And in the most important votes in the Parliamentary Assembly of the Council of Europe it was then really only the delegations of deputies from East and Central Europe who tried in vain to stop Russia.

In the end I ended up with a terrible migraine in an ambulance on the ground floor and I realized that it was high time to return home with Emma.

I was recently at a conference at the Council of Europe. After 20 years I walked sadly around the building and read Russian names on the doors of important offices. All real power has shifted to the European Commission, and the Council of Europe has been destroyed from the inside. It is no longer going to lecture anyone about human rights; Russia will make sure of that...

But the twilight of democracy does not affect only Europe, but also America.
For ten years I have very much enjoyed teaching clever young people at the university: American students who are over 20. I think that American university students are more and more often coming to Europe to study because they feel desperate about the state of democracy and about Donald Trump. This evidently weird American populist denies everything in which democrats believed during Barack Obama's term of office, and even young Republicans are in a state of total despair because of him!

Trump of course has been supported by the Russians for many years.
And for the first time they are experiencing for themselves in America what it is like to live in a society that is more and more intolerant, and dominated by one person. My subject, which is entitled 'Nazism and Communism in Literature and Film' is being chosen by more and more American students because they want to find out how it is at all possible for a totalitarian regime to arise and to last, and how to deal with such a regime. I agree with the psychologist Scott M. Peck that every person, and young Americans today in particular, must harness all their energies in order to succeed in demonstrating that Donald Trump is a man of lies.

We must perform the same work here in the Czech Republic. We must also show that Václav Klaus, Miloš Zeman and Andrej Babiš are men of lies. In Slovakia, where they are really trying, citizens also have to carry out this hard work, as they must also do in Poland, where they have a tough opponent in Kaczyński, and in Hungary, where they have only just recently started realizing how to go about opposing the demagogic Orbán.

At the same time in those Western democracies that have lasted a long time, such as France and Germany, it is also necessary to renew trust between the ruling elite, political representatives and the public. Because we are all now following the attempts at reform by President Emmanuel Macron and we see that, lo and behold, the Yellow Vests immediately take to the streets in France...

The Yellow Vests are also supported from Russia. And Brexit as well.
Brexit certainly. Russia and China are gradually succeeding in undermining the principles of Western democracy by supporting various dissatisfied layers of the population in Europe. They are even infiltrating into some NGOs and into the media. They are unbelievably active on social media. This hybrid war that they are now conducting is much more complicated than the first, second and cold wars, because in those wars good and evil were still in some way defined. Whereas now this battlefront between truth and lies goes through every town, every school, every company...

Do you have any hope that reason will prevail in this confusion of opinions in the world?
I still retain hope within myself. After all we thought that we would live under communism for ever! Now we sometimes have the feeling that we are going to live in this chaos, lies and disinformation for our whole lives.

On the 30th anniversary of the Velvet Revolution we have a great opportunity to realize that in the past we have been in a far worse situation, that we were an occupied country and that we really had only our bare hands. During these years in freedom we have gathered knowledge, experiences, documents, testimonies, evidence...

And it is up to us, to every citizen individually and at the same time to the whole of society, to make use of this knowledge and this conviction in our everyday ordinary work, as Tomáš Garrigue Masaryk already called upon us to do.

Interview conducted by Olga Sommerová 4. 1. 2019, Prague.

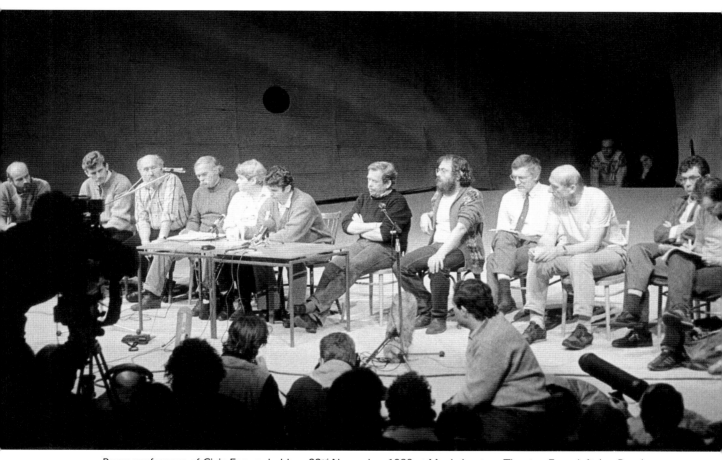

Press conference of Civic Forum, held on 22nd November 1989 at Magic Lantern Theatre. From left: Jan Ruml, Aleš Lederer, Jiří Kantůrek, Ladislav Lis, Rita Klímová, Václav Malý, Václav Havel, Vladimír Hanzel, Václav Klaus, Jiří Černý and Petr Čepek. (ČTK / Petr Mazanec)

JOLYON NAEGELE

You have been following events in the Czech Republic and in central Europe as a whole since the time of your university studies. Can you try to put what is happening today into the context of what has happened here during the last 30 or 40 years?

I was here every year from 1973 until 1980, thereafter I was in Czechoslovakia almost every month until 1990, when I finally moved here as a Czech-speaking foreigner, albeit one who has concerned himself with Czechoslovakia for his entire student and working life. Czech society was always a tad mysterious for me. On the one hand, there was an impressive culture here, but on the other hand, society in the Communist era was closed, having been weakened by half a century of totalitarian rule, during which much of the country's Jewish and Roma populations had been exterminated, the upper and middle classes had been dispossessed and in many cases fled in multiple waves of emigration, and much of its industrial heartland – the Sudeten German borderlands – were depopulated by flight, transfer and expulsion. Long before November 1989, I used to wonder, if there were free elections some day, what share of the population would vote for the Communists – 40 or 50 percent, or no one? It really was quite impossible to detect this with any degree of certainty. As one never could be sure with whom one had the honour of speaking, most people were cautious in openly expressing their political views.

As a correspondent for Voice of America you monitored the demonstrations during Jan Palach week, when riot police intervened, including, among others, current Communist parliamentary deputy Zdeněk Ondráček, who was then a member of a Public Security (VB) riot police unit. How did you perceive this at the time?

On the personal level during the events in January there was a culmination of pressure exerted on me by overly zealous StB (State Security) agents. This pressure made itself felt on 10th December 1988 in a typical StB provocation.

That was Human Rights Day and the demonstration on Škroupovo Square.

Yes, and precisely on my way to this demonstration, I was physically attacked and threatened with expulsion in the vestibule of the Museum metro station by a plainclothes police officer accompanied by one in uniform. This was a typical attempt at intimidation. The American ambassador to the CSCE (Conference on Security and Cooperation) in Vienna, Warren Zimmerman, then publicly complained at a plenary session to Foreign Minister Jaromír Johanes that such state-sponsored chicanery was completely unacceptable – Czechoslovakia had committed itself internationally not to obstruct the work of foreign journalists: "You want something from us (organising a CSCE conference in Prague on economic cooperation)? And this is the way you behave toward accredited journalists?" Zimmerman told Johanes, adding that under the circumstances the U.S. would not agree to the Czechoslovak proposal to hold the conference in Prague.

During Palach week on Wenceslas Square, the StB sprayed a white stripe on my office vehicle and let the air out of all four tyres. On the same evening a character similar to Ondráček stopped by at the hotel to record a protocol of the incident – a young ambitious SNB (State National Security) officer who started boasting that earlier that week he had taken Havel into custody. He wanted to know if I suspected anyone. In view of the fact that Wenceslas Square had been completely cordoned off, it could only have been someone from the StB or the SNB. The next day, I was summoned to the police station in order to amend my original estimate of the damage, and at the police station in Školská Street I was told to ask for a certain Inspector Hausmeister (as it turned out, this was not his real name).

At that time I told him: 'Look, I don't understand this. Every time when at the turn of the year I receive an accreditation for a further period of time, shortly afterwards I have some experience like this. What's going on? If they don't want me to be able to do my work freely, then why do they accredit me?' His response was, 'Don't you understand what is going on? The people at the top feel threatened; they know that their time is almost up.'

He told you that openly?
Yes, a uniformed SNB officer. Understandably just between the two of us. Of course I could not let such a statement just pass by and I put it in one of my reports – according to police sources, the situation in Prague and so on... Ivan Medek in Vienna then commented: 'If an SNB officer told you this, then something is really happening.'

Colleagues from various media outlets who were here in the same period as me quickly wrote books after November 89 about how they experienced this, but I refused to do so, because too many things remained unclear to me – not only the collapse of Communist power, but generally how things had functioned here.

Was your StB file preserved?
Yes. I continued to be under occasional surveillance up until the middle of the 1990, and the investigation into my activities was only halted in October of that year when the federal interior ministry closed the file on me. Hence my file in contrast to so many others was not destroyed.

Who was following you? The StB was disbanded at the end of January...
After the StB was dissolved, my case, together with the investigation into me, was transferred to the federal interior ministry. When I then read my case file in 1996 – roughly 1,200 pages of denunciations from agents, reports from monitoring operations, a list of wiretapped conversations, protocols of various events, unfounded speculations and nonsense – I finally understood how the system then actually functioned.

During your reading of the 1,200 pages of this nonsense what surprised you most?
I was surprised by the extent, the depth and also the stupidity of this spying. One of the worst secret collaborators in my case – who exactly this was, I will save for my memoirs – was a person who in 1981 denounced me as a "probable élève" of the CIA merely because I was a young American who knew Czech and knew quite a bit about the situation here. And he made this accusation on the basis of one telephone call in which I asked him, professionally, since he was the Prague stringer of my employer, a Vienna-based weekly on East-West trade, whether he could help me schedule a series of interviews that I wanted to do in Prague.

So, you were not a CIA agent.

No, I was not. However, on the basis of this denunciation, the StB launched an investigation, opening a 'signal' file on me on suspicion of espionage. They kept me under surveillance for nine years but by their own admission found no evidence that they could ever use against me in a public trial. What is ironic is that a year and a half later, the same informer, with whom I had an excellent working relationship, denounced me as a possible KGB agent... In early 1989, the StB proposed ending the investigation, closing the signal file and opening a new file on me as a "screened person".

And you were not a KGB agent.

I was not a KGB agent either. The StB lost no time in sending a formal request to "our friends", their term for the KGB liaison officer at the Soviet embassy in Prague, for information about me, and within two weeks they had received a very detailed three-page profile in Russian of my activities, friends, acquaintances, colleagues etc. in Vienna...

From Moscow?

From Vienna via Moscow, evidently, because I was then living in Vienna. When I read it, it was more detailed than any diary I might have written – these three pages were perhaps a better piece of intelligence work than the entire 1,200 pages that the StB and its informers had produced about me over the years. This elaboration then ended with the words that I was not therefore their man. However, this was then followed by various Russian attempts to recruit and monitor me.

In Vienna...

Both in Vienna, and subsequently also in Prague.

How did this take place?

It was all surprisingly transparent. I may have been young, but I was not so naïve. I had studied Soviet foreign policy for my Masters degree from Johns Hopkins University and I spoke good Russian. For instance, I was invited to a reception at the Soviet embassy in Vienna on the day of Soviet journalism. One older diplomat introduced himself to me, but he did not give me his business card, which he did nevertheless give to other diplomats at the reception. The next day he called me to invite me to lunch. I phoned a British diplomat whom I had seen being given the Soviet diplomat's card at the reception to read the name on the card. I then looked the name up in a useful book I had about the KGB by John Barron which contained the names of expelled KGB agents all over the world, and – surprise surprise – he was one of those listed in there. He invited me to a meeting several times, and I always excused myself by saying I did not have time. Until eventually on the telephone one day he said to me: 'But you do have time, if not for lunch then maybe for dinner – you're not married, you do not go out much in the evening...'

Ha ha.

And I replied: 'That may be, but nevertheless I still don't have time to meet.'

Or, when I went to the Soviet embassy for a visa, because I wanted to go to Moscow, privately. The Soviet consul told me that, as I spoke German and Russian well, and they needed translators, perhaps I could do something for them sometime. When they then issued me with the visa, I noticed that one of the numbers was circled in green ink. I showed this to an acquaintance, a former diplomat, and in the end I decided to cancel my trip.

Then a Czech friend of mine suggested that he could organize a visit to the Soviet military base at Milovice; he said that he had been there and it was really interesting. But I was really not so foolish. There was absolutely no way I was going to visit the Soviet military base at Milovice. It was recorded in my file that Soviet and Czechoslovak military intelligence as well as the StB had approved a plan to lure me to a Soviet base on the outskirts of Prague on some sort of 'open-door day' and this 'friend' would lend me a pair of binoculars or a camera, at which point they would arrest me.

They wanted to set you up for espionage, and then blackmail you and offer you the option of co-operation?
That is one possibility, but I suspect that they wanted me as a "pawn" to trade for a real spy as subsequently happened to an American journalist, Nicholas Daniloff, who was given a package in the Moscow metro and then immediately arrested for espionage and subsequently exchanged for a real spy.

How did you come to your knowledge of the Czech language, and to your interest in eastern and central Europe?
In addition to my love of the Beatles as a child, I was also very interested in classical music and virtually every morning I listened to Smetana's Vltava (Moldau) on an LP – I really liked Smetana, and Dvořák as well. This all started when I saw a short film for children on television about a river, which was accompanied by Smetana's Vltava. This interest only increased thanks to developments in 1968.

Did you follow events in Czechoslovakia at that time?
I did. There were multiple reports direct from Czechoslovakia daily on U.S. television during the Prague Spring. After the invasion, there was far less on TV, but *The New York Times* was full of stories about the occupation and the fate of the leaders of the Prague Spring. A growing number of books were subsequently published in the U.S. about the Prague Spring and its suppression. I read whatever books I could get my hands that had anything do with Czechoslovakia in public and university libraries years before I started university. The library in the town near our weekend cottage had a pre-1948 edition of an album of Karel Plicka's photographs of Prague, which I found entrancing as well as a copy of Josef Škvorecký's *Cowards* which I read. In 1965 or 1966 my uncle, a violinist, visited Prague with the Cleveland orchestra, returning with another book of Plicka's pre-war photographs, this one of Slovakia. So, I fell in love with a Slovakia which no longer really existed, although in remote places in the 1970s and '80s I did find elements of daily life not far removed from what Plicka had captured. The only required reading from Central Europe in high school was Kafka's *Metamorphosis* but I read a variety of literature set in Poland and further east: chiefly the books and short stories of Isaac Bashevis Singer as well as Jerzy Kosinski's *Painted Bird* – which my 11th grade history teacher highly recommended to me and which I devoured in a night or two..

The films of the Czechoslovak New Wave also made a big impression on me, notably Jiří Menzel's *Closely Watched Trains* and Ján Kádár's and Elmar Klos' *The Shop on Main Street*, which to this day still offers the best insight into the functioning of everyday life in a fascist state. In large part this is because it was filmed in 1963, when the fascist Slovak State was still relatively fresh in the memory of the creators and actors.

A few years later, Vojtěch Jasný's *All My Countrymen* was a real discovery for me. I saw it in Washington, where Antonín Liehm had organized a festival of Czechoslovak film at the Kennedy Center in early 1978. I remember that at the time, I told my professor, Vojtěch Mastný, that viewing this film should be compulsory for anyone wanting to study central European history and to understand Czechoslovakia. There were also several excellent Polish films I saw, for instance Polanski's *Knife in the Water* and then of course Wajda's *Man of Marble*. But my preference was for Czechoslovak films, which I really love.

And then I travelled. In 1973, when I was 18, I was able to travel on my own through Europe, including to Czechoslovakia, I financed the trip from after-school earnings. I finally saw the Iron Curtain with my own eyes, and the closed society I encountered behind it made a deep impression on me. While visiting Vienna and Prague on that trip, I immediately knew that my fate was bound up with these two cities. I fell in love with Prague in spite of the fact that as the metro was under construction the city centre was one big construction site – Náměstí Republiky (Republic Square), Příkopy and so on. The air quality was awful that summer. On that and subsequent visits I found it rather difficult getting to know people in Prague. In contrast, the people I met elsewhere, notably in Brno, were generally much more open. On a visit in 1976, I took my father, a graphic artist, with me. We visited Prague, southern Bohemia, Brno, Olomouc, the Tatras and Spiš, where over a few days he painted several landscapes and village scenes around Ždiar and Lendák.

How was your start at Voice of America?
VOA's Vienna correspondent at the time, David Lent, saw in me a potential successor; he arranged for Edward DeFontaine, director of VOA's News and English Broadcasts, to meet me in Washington. DeFontaine had a big office with a big American flag and a spectacular view out the window of the Capitol – like in some film. He told me that if it were solely up to him, he would hire me on the spot, but that I had to get a security clearance first. That took from January until the end of July 1984, during which I had to account for every night I ever spent behind the Iron Curtain, where and with whom…

Once cleared, I went to Washington for a two-month training period in VOA's central newsroom, which was very useful, and in the end they sent me back to Vienna as bureau chief and East Europe correspondent. Sometime in March 1985, I received accreditation in Czechoslovakia, after the U.S. Embassy had made the freedom of movement in the U.S. of the Czechoslovak Radio correspondent in New York contingent on Prague granting the VOA correspondent for Eastern Europe journalistic accreditation. Within two weeks of the U.S. ultimatum, the international section of the Communist Party Central Committee made a positive decision – after the Czechoslovak foreign ministry and government had both already rejected the application.

How did the StB react to this?
They kept me under close surveillance and sought to expand their network of agents since by their own admission, following me around was counterproductive since I would mention in my reports that I was followed and harassed. However, as is evident from my file, the StB was neither all-powerful nor all-knowing; its right hand did not know what the left hand was doing. The intellectual level of investigators was generally quite limited and there was an excessive reliance on informers for intelligence which all too often turned out to be inaccurate or false. Moreover, maintaining a semblance of a conspiracy of secrecy proved increasingly difficult as

public trust in the system disintegrated. Some in counterintelligence perceived me as a potentially dangerous element and repeatedly sought to get my accreditation cancelled. For example, in late 1987, a counterintelligence major met with an StB major working in the Foreign Ministry press department and requested that my accreditation not be extended. The request went all the way to the foreign minister, who rejected the request saying it was not in the interest of Czechoslovakia's domestic or foreign policy, that Prague was bound by the Helsinki Accords and related CSCE agreements, and that I should be allowed to carry out my journalist work like any other accredited foreign correspondent. The StB nevertheless proceeded to make things as unpleasant as possible for me.

It should be noted that in the first half of the 1980s, at least up until 1983/84 the StB investigators whose responsibility it was to keep tabs on me generally took their work relatively conscientiously and responsibly. Every three months, they analysed what they had ascertained, allocated new tasks for what they should look for in the coming period, and so on. However, around the mid-1980s there was apparently a change of personnel. There was a slightly younger bunch of people there, a rather primitive lot who did not bother making any effort at ascertaining whether I or the organization for which I was working were free of any affiliation with foreign intelligence agencies; they simply regarded it as self-evident that as I was an American and I knew Czech, I must be a CIA agent! I have a cousin who worked at Reuters and on one occasion travelled with me to Brno and Prague, hence he was in their eyes a British agent...

But this was the way that a communist counterintelligence service functioned which was founded on the idea that, if they followed everyone and everything, then it would be almost impossible not to find anything... The entire regime was based on mistrust, automatic suspicion, automatic spying and informing on others – from the kindergarten to the funeral parlour.
Yes, but as its intellectual level was so mediocre the StB was often not in a position to recognize truth from fiction, factual reporting by its informers from fabulation, in which some engaged in an effort to boost their prestige with their control agents.

How did your communications with Prague function?
A key moment was when in the mid-1980s, an agreement was reached on the opening of a high-capacity telephone cable between Prague and Frankfurt on Main.

Which it was difficult for them to monitor...
Yes, up until that time, when I phoned Brno or Prague from Vienna, then as soon as anything sensitive was mentioned, the line immediately went dead and could not be reconnected. If Havel, Dienstbier or Uhl wanted to get some information out, then someone had to be entrusted with physically taking the written reports for example to Budapest or else taken out by diplomatic pouch; that meant weeks-long delays in disseminating news. However, with the new high capacity cable, all of a sudden the reports that we were broadcasting were fresh, and because the Voice of America broadcast on medium wave was not blocked, our listenership skyrocketed. I remember how while I was covering a story in Hungary, the BBC's head for Central Europe broadcasts came to Budapest in a bid to persuade me to work for them instead of the VOA. He noted that since 1984 the BBC Czechoslovak service had lost a lot of listeners to the Voice of America.

I telephoned reports to Ivan Medek from a public telephone box in Mostecká Street for free at the expense of the communist telecommunications company, because the phone was 'out of order' and it took them several months before they discovered this. But that was 1988.

Yes, by then that was possible, but not in the early 1980s. For me, the breaching of this information barrier meant the beginning of the end for this regime, because information is power. Whoever has reliable, substantiated information can make correct and timely decisions.

Did the Communists listen to the Voice of America?

Yes, of course they did; everyone did. The *nomenklatura* received monitoring reports. I once broadcast a commentary about the fact that since 1969, President and Communist Party General Secretary Gustáv Husák had been afraid to utter the word reform in public. A couple of days after the broadcast, Husák delivered a speech at a plenary session of the party's central committee in the Spanish Hall of Prague Castle, which was then published on a whole page in *Rudé právo*, the party newspaper. Husák asserted that some were voicing the suggestion, that he, Husák, was afraid of the word reform, but that this was not the case. Ha ha. Then it began to dawn on me how weak they really were, how afraid they were and how they felt the need to react to anything they perceived as criticism and that, as I had been told by some of my Czech and Slovak sources, my broadcast reports gave me far more power than I could possibly imagine. Until then, I had scoffed at such suggestions.

Did you read the communist press regularly?

Yes, every day I received *Rudé právo* and Slovak *Pravda* on my desk, plus several weeklies. I also watched the Czechoslovak television evening news and received daily media monitoring reports of the U.S. Federal Broadcast Information Service and of the Czechoslovak Service of RFE/RL, so I was quite well informed.

What was it like to work with Ivan Medek? [An exiled dissident who was a stringer in Vienna for VOA's Czechoslovak service, and who served as a key interface between Czechoslovak dissidents and the western news media, by maintaining daily telephone contact with the dissident community, disseminating statements of Charter 77, VONS and other independent initiatives and providing his own insights.]

Our cooperation was exemplary. Every day at around three or four in the afternoon, Ivan Medek used to come in to deliver his reports, which were sent by telephone to Washington from our audio studio in Vienna. He always gave me a printed version, which I immediately translated into English, processed into news reports and forwarded to VOA in Washington for use by the other language services.

Were you his boss?

No, I wasn't, other than signing orders for his monthly pay-check; he was an external staffer.

When did you establish contacts with Czech dissidents?

Only in the mid-1980s, when I was at the Voice of America; prior to that I did not have any opportunity and moreover I did not seek out something that could have resulted in my no longer being granted a visa. But long before joining VOA I had friends in the cultural sector, in Brno, some of whom had signed Charter 77 and who had contacts with Havel and other dissidents. I first met Havel only in early 1986.

How did this take place?

The meeting was arranged by Václav Havel's brother Ivan and their friend Zdeněk Urbánek. I remember that it was a Sunday morning, that Václav Havel was invited to drop by at Zdeněk Urbánek's flat while walking his dog. He knew he was going to meet someone at Zdeněk's but did not know whom until we were introduced. This was shortly before he was to be awarded the Erasmus of Rotterdam prize, which had already been announced. I remember that he told me that he had to choose his words very carefully in order to avoid ending up being interrogated at the Bartolomějská street police station immediately after the interview was broadcast. After he moved across the river into the flat he and Olga shared with Ivan and Dagmar, I visited him to record interviews on several occasions.

I also visited him at his cottage in Hrádeček, for example in August 1988 to record his views on the 20th anniversary of the occupation while I was touring Soviet garrison towns on the territory of Czechoslovakia, talking with local people, but mainly just gathering impressions of the on-going impact of the Soviet military occupation.

I had already seen Havel several times before I actually interviewed him. Once was at a reception at the American ambassador's residence shortly after he was released from prison in 1982 – he was surrounded by other dissidents, at the time still unknown to me, and diplomats, and I was really a kind of nobody at the time and so I did not have the courage to introduce myself. The second time was at the funeral of poet Jaroslav Seifert in January 1986 in front of Rudolfinum, where they refused to let Havel in, and so he was standing with a few friends in the closed-off 17. listopadu (17th November) Street and they were estimating the number of people who had come to Rudolfinum to pay their respects to Seifert. I was surrounded by StB agents and I kept out of the way. A couple of hours later I saw him again, this time being denied entry into the cemetery in Kralupy for the burial. Just moments later, after I entered the cemetery, I was in police custody. This was the first time I was detained in Czechoslovakia.

Under what pretext did they detain you…

Journalists were strictly forbidden from recording anything there, but I did not want to leave expensive technical equipment in the car, so I took a bag with me, placed it on the ground, stood by a grave to get a better view of the speakers, and at that moment a burly guy grabbed my bag and left the cemetery with it. I shouted at him, but he just got into the front of a Lada and his buddies shoved me into the back of the car. I asked: 'Why are you arresting me? You have no right to do so!' To which he cited a paragraph of the penal code that I was merely being detained but not arrested. He did not say any more and we set off. We eventually turned down a dirt track into the middle of a field, where another car was waiting. They transferred me to this car and we then continued – a sort of psychological preparation or else they just needed to keep me occupied and incommunicado for the duration of the burial. In the end they parked in front of the police station in Kralupy. They left me sitting for half an hour in a kind of waiting room, where there was a Czechoslovak Railways timetable and a portrait of the president on the wall, and nothing else. The doors remained half open, and so every now and again I had a quick look out and I saw guys dressed in black mourning clothes walking down the corridor – 'mourning guests' from the cemetery who were in fact StB agents or staff who had attended the funeral to monitor and make reports. Some of the faces seemed vaguely familiar to me.

After half an hour, an older man dressed in a black suit told me that I could go, that my documents were in order. So, I set off on foot and eventually found my way back uphill to the

cemetery. In the meantime, the U.S. embassy had already received a notification from a colleague that I had been detained, and they immediately protested and requested an explanation from the Foreign Ministry. In the end, an explanation which convinced no one was offered: that the security officers had detained me due to their suspicion that a bomb was concealed in my bag. This was despite the fact that the StB officer who had confiscated my bag had it on his lap throughout the trip to the police station.

Whom else did you interview?

Ivan Medek recommended that I meet Father Josef Zvěřina, a persecuted Roman Catholic priest, theologian, art historian and philosopher. This was one of the first and also one of the most fascinating interviews that I did for the Voice of America. Unfortunately, it was the only one with him, because he died less than a year after the Velvet Revolution. I also did an interview with Cardinal František Tomášek. Gradually I got to know Jiří Dientsbier and Václav Benda, and later on the people from Obroda (Renewal). I got on best with Dienstbier. As fellow radio journalists, we understood each other, I visited him numerous times and it was really pleasant, in spite of the smoke from his cigarettes. At Havel's place there was usually a small obstacle – his wife Olga, who tried to make sure that people did not bother him too much. I always had the feeling as if I was sitting at some writer's or artist's place in New York, but one which had a view across the river to Prague Castle instead of across Central Park. In contrast to Dienstbier, with whom I was on first name terms, I always remained on formal terms with Havel – he was not the only one who had problems pronouncing my first name and surname. I also frequently interviewed among others Vlasta Chramostová, Věnek Šilhán and his wife Libuše, Petr Uhl and Anna Šabatová, and in Bratislava, Ján Čarnogurský, Milan Šimečka and Alexander Dubček.

Lída Rakušanová with Pavel Tigrid and Petr Brod at Radio Free Europe (Josef Rakušan)

Were you surprised by the large size of the demonstration on 21st August 1988 in Prague?

Yes and no. I had been at the 'candle-light' demonstration in Bratislava on Good Friday earlier that year, where the police had overreacted, so I suspected that the state authorities were prepared to intervene with force against any kind of protest gathering. I was curious whether only a handful of people would show up to publicly commemorate the invasion. On the other hand, plans to stage the gathering in Prague had received publicity through the Voice of America, the BBC and Radio Free Europe. On Saturday, August 20, there was a peaceful, dignified demonstration on Wenceslas Square; to a certain extent it was a surprise that this passed off without serious incident. It was not very big, but the next day in the evening, the square was suddenly full of people. More and more people arrived, and then the crowd started to move down Wenceslas Square to Můstek, and then to the Old Town Square and eventually to the embankment in front of the Slávia cafe, where thousands of people had gathered and were chanting various anti-regime slogans. The situation very quickly came to a head when the StB staged a provocation by trying to forcibly detain a young blonde woman in a white dress in the crowd, in response to which people whistled and chanted. A man, perhaps her partner, tried to protect her and he was beaten while she was dragged away screaming in fear. I was surrounded by StB officers. I could not do much, as they were standing to my right and left, waiting for an opportunity to drag me off, so I merely observed. Then, as the sun set, the police and members of riot police units started to disperse the crowd by force, chasing and beating protesters on National Boulevard (Národní třída) and along the adjacent embankment. I went back to my hotel and sent a detailed report about what I had witnessed, the slogans the protesters had chanted and so on.

Were you at all the anti-regime demonstrations?

Yes, I was at all the bigger ones.

Did StB officers attack foreign journalists?

At one of the smaller demonstrations which I was not at – I believe it was in November 1988 – they attacked an American reporter from the Reuters news agency, Michael Wise. The StB officers told him to stop writing, in Czech, which he did not understand at first and he continued making notes in his notebook, so one of them bent his thumb back until it fractured. On another occasion during a street protest, some colleagues ended up getting chased along with protesters into the so-called "mouse-hole", in StB jargon, an alley leading into a courtyard off Opletalova Street, where they were harassed for a while before being released. However, most StB harassment of foreign journalists was limited to keeping them under surveillance and occasionally stopping them to check their documents. Many but not all local stringers of foreign non-socialist media were StB informers.

Did you speak with any of the Communist potentates?

For instance, shortly after Havel's arrest in January 1989, I interviewed Vasil Mohorita, the head of the Czechoslovak Socialist Union of Youth and ostensibly the youngest member of the Communist Party's Central Committee. Then, before the demonstration in October 1989, I was in Vienna to attend a news conference held by visiting Czechoslovak Prime Minister Ladislav Adamec. I asked him what we could expect in Prague on the 28th [Czechoslovak independence day] as the authorities seemed to have been using different tactics at each demonstration, allowing some while violently dispersing others with water cannon and truncheons. Adamec's

responses to reporters' questions reflected insecurity and he actually lost his temper, branding a perfectly legitimate question posed by an elderly West German correspondent as a "provocation". But Adamec was certainly no primitive, in contrast to Vasiľ Biľak, with whom I spoke briefly during his visit to Vienna. On that occasion I had received a telephone call from the Czechoslovak embassy press attaché, inviting me to the ambassador's residence for a cocktail. He did not tell me who was going to be there but the assumption among reporters was that it would be Biľak as he was in town on a rare official visit.

We foreign journalists stood around Biľak with drinks in hand; after briefing Czechoslovak journalists, he responded to a few of our questions. This was a day or two after the visit of an American senator to Prague, whom the StB had harassed in front of the home of Petr Uhl and Anna Šabatová in Anglická Street. They had requested his documents, but as he did not have his passport on him, just his hotel ID, which was not enough for them, then told him to move on. So, I asked Biľak whether this had been based on orders from above in order to prevent the senator from meeting the Uhls, and he replied 'Orders? There were no orders. You know what? In Prague, in the evening, at night, it can be dangerous. All kinds of things could have happened to him. This was just for his own safety.'

When did you first succeed in speaking with Dubček, who rather tended to avoid interviews…
For a long time any journalists or diplomats who tried to approach his house had been stopped by the StB, who did not allow anyone to get to him. I had wanted to do an interview with Dubček for years, but I did not want to risk being expelled and banned from the country. So, I bided my time. Then, while I was stuck in Romania after a road accident in November 1987, I heard that

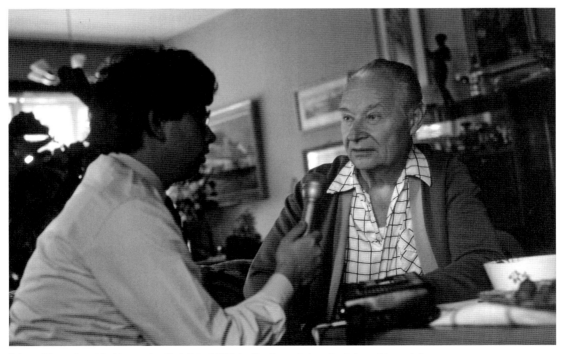

Jolyon Naegele with Alexander Dubček, 1988 (self-taken picture by Jolyon Naegele)

a colleague from *The New York Times*, Henry Kamm, had made an official request to the press and information centre for foreign journalists in Bratislava to organize an interview with Dubček.

So, after I made my way back to Vienna, I also made an official request by phone to Bratislava. A day or two later, I received a very interesting reply: we cannot arrange this interview, because the gentleman with whom you wish to speak is a private person. I thought, this is good news! He is not classified as an anti-state element or a traitor, but merely a private person! So, together with Misha Glenny, who was then working for *The Guardian*, I set out the next day from Vienna for Bratislava. We parked a good way off from the house where Dubček lived and continued on foot. We rang the bell and a well-known face poked his head out and then came down to the gate: 'And who are you?'

We are reporters from *'The Voice of America* and *The Guardian.'*

'I don't give interviews.'

'We don't need to do an interview now. We would just like to talk with you'

He looked us over, examining whether we were provocateurs or not, while we explained to him exactly what we did and how come we both spoke Czech and even some Slovak. He looked at us for a while longer and then said: 'Okay, come on in – but no interview! If you use any of this, then you'll never get an interview with me ever!'

When was this?
This was in November 1987. We sat with him in the foyer of his villa. The walls of the room were decorated with hunting trophies mounted on plaques stating when and where the animals had been shot: Topolčianky, Židlochovice, Lány and so on. He spoke with us for nearly 30 minutes.

About what?
In essence he was frustrated with the state of the country under a discredited regime and that his best years were gone. He wanted his honour back. Regarding a possible interview he said that he would let us know when the right time came. Then a few months later when I received an Easter postcard from him, signed AD, I understood that the time had come, and I set out to visit him once again. However, Dubček only came out on the balcony in his bathrobe to say that he had tonsillitis and that he could not receive me. We finally conducted our first recorded interview in June 1988.

Did he speak openly? Did he want to see the questions in advance?
In May 1988, we sat down together and discussed the issues that should be in the interview, but he wanted a bit more time to prepare for it. Hence, due to my travel schedule, we recorded the interview the following month, after I came back from holiday in Turkey. I brought him a bottle of raki spirit as a souvenir from Turkey and a reminder of his brief exile in Ankara, where he had been sent into exile as ambassador in 1969. He later told me that the Husák régime had hoped that he would defect to the West while in Turkey and thereby discredit himself, but that he failed to do and so he was recalled in June 1970. He welcomed me at the door with a script and said: "here are your questions, in Czech, and my answers, in Slovak". We spoke extensively on this and other occasions on and off-mike, understandably about 1968, about the invasion and his abduction to Moscow but also about his life. I asked him why, after what he had to experience and see with his own eyes while he was growing up in Bishkek in Kyrgyzstan in the 1920s and 30s, when the parents of who knows how many of his fellow pupils must have disappeared, he

nevertheless joined the Communist Party shortly after his return to Slovakia – surely he must have understood what Communism represented. Of course, he was on the defensive, but he claimed that, after the Munich Agreement in 1938, the pro-Western non-communist parties had been discredited, that joining the fascists was unthinkable and the only thing remaining if one wanted to be engaged was the Slovak Communist Party. Then he spoke about Antonín Novotný, his predecessor as Communist Party first secretary, who did not like him, and about how it annoyed Novotný that he, Dubček, had been favoured by Khrushchev, who had insisted that he sit next to him in his limo as they toured Slovakia...

Was he open or did he hold back?
No, he was open from the start and ever more so on subsequent visits.

How do you view the character of Dubček? He annoyed us terribly, our generation, because of his pliancy and subservience..., even though this view is possibly a little bit juvenile.
That's a good question. For me, as a 13-year-old boy who was interested in Czechoslovakia in 1968, Dubček was a hero because he represented what appeared at the time to be a viable alternative to the repressive regimes throughout the Soviet empire, enabling freedom of speech, the end of state censorship and allowing Czechoslovak citizens to travel to the West and to hope for further political liberalization. Of course, over time my views changed after I became aware of the significance of the Moscow Protocols. Much later, when I was at VOA, Ivan Medek explained to me the impact of Dubček's submission, albeit under pressure, to the Moscow Protocols. Dubček was a contradictory figure. He had charisma, but due to his life in the party hierarchy he was unable to see beyond the immediate horizon, let alone overcome his ego and sense of having been unjustly persecuted. Obviously, even if it was another era than in the aftermath of the Hungarian revolution in 1956, he did not want to share the same fate as Imre Nagy and Pál Maléter, who were executed in 1958. Time has shown that Dubček and Gorbachev shared some common attributes of character and experience in having been somewhat removed from reality. As is clear from various documents, Dubček was a tragic figure, torn between what was happening in the spring and summer of 1968 and the disintegration of party discipline, admitting his powerlessness to rein in the more liberal elements in his famous telephone conversation with Leonid Brezhnev a couple of days before the invasion. Nevertheless, Dubček remained for me a symbol of hope and decency, in contrast to all those party hacks who abandoned the ideals of the Prague Spring, agreed with the invasion, were fully subservient to the region and then after the collapse of Communism turned their insider knowledge into unimaginable wealth by "tunnelling" firms that were being privatized. For them, all that counts is power, privilege, material benefits and being above the law.

However, Dubček's 'tragedy' had a continuation – in my opinion, he did not at all understand the changes at the end of the 1980s.
Yes, he had remained in the shadows and avoided contact with the dissident community with the exception of a few friends in Obroda. He was naïve in imagining that 20 years of living in disgrace after his ouster, he somehow would lead the country anew. I was surprised by how quickly he aged in the last years of his life. The last time I spoke with him was at a reception at the British embassy on the occasion of the queen's birthday, less than three months before his tragic car accident. This was shortly after the elections, and I asked him what role he expected

to play, in view of the likelihood of the Czechoslovak federal state breaking up. He replied that, as there was unlikely to be a place for him in the leadership in Prague, he would return to Slovakia, indicating he might well run for president there. He wanted to continue to serve and use his reputation abroad, which could be of some use for the new state. However, he was seriously injured in that car accident on the highway near Humpolec. I cried when he died two months later following steady deterioration in hospital. He didn't deserve such a death.

From what moment, in your opinion, is it possible to trace a direct path to November 1989?
Things started moving with greater speed from the Palach week in January 1989. The day Havel was released from prison after four months behind bars, May 17, he recounted in an interview with me how impressed he was with how much had changed in society during those four months, notably the plethora of new, outspoken civic initiatives but also how his treatment in prison had changed for the better. Nevertheless, as long as Czechs and Slovaks were afraid to demonstrate on a massive scale to challenge the regime, nothing fundamental could happen or change. In the end it was Moscow's passivity after the fall of the Berlin Wall and the opening of the borders of East Germany on 9th November that enabled the Velvet Revolution to succeed in the Czechoslovak Socialist Republic.

Did Palach week represent a psychological turning point in society?
That may well be the case, but at that time my perception was that the ruling authorities were already in crisis. Neither the president's office at Prague Castle, nor the party leadership, nor even the StB, knew what they wanted beyond holding on to power for dear life and not ending up having to answer for their misdeeds of the previous two decades, which ran the gamut from treason to corruption. In the course of 1989, a number of things happened in quick succession, and as during the Prague Spring, the leaders were no longer fully able to monitor, analyse and respond to developments which were taking place at an accelerating pace. They simply were not up to the task intellectually or physically and could no longer rely on Soviet political, security and military support.

 For me there were multiple turning points: the Good Friday demonstration in Bratislava in March 1988, the mass protests and violent police repression in Prague on August 21 and October 28. Palach week was a culmination of what had been set off by these three milestones.

Where did you experience 17th November?
I was in East Berlin, covering the aftermath of the opening of the Berlin Wall. I knew that a student protest demonstration was scheduled in Prague, but little more than that. On Friday evening, the 17th, West German television reported that a large demonstration in Prague had been violently dispersed, during which at least one demonstrator had reportedly been killed and many more injured. The entire following day I followed events very carefully, and in the evening, when West German TV reported that possibly a second student had also been killed, I could no longer contain myself and I tried to phone my boss in Washington. However, I could not get hold of him, so I informed my colleagues that I was going to Prague without the standard approval by the chief of assignments in the newsroom. I already had a valid Czechoslovak visa – a few months earlier I had obtained a multiple entry visa shortly after the foreign ministry loosened the rules for accredited correspondents. And so, I headed off to Prague. Shortly after crossing the border, I picked up a couple of student hitchhikers who recounted having par-

ticipated in unprecedented protest rallies in Teplice the previous week against environmental pollution and were now on their way to protest in Prague.

So, that was on Sunday 19th November.
Yes. As usual, I had reserved a room with balcony at the Hotel Jalta, and when I arrived there, the receptionist, an StB informer, said to me: 'I little bit late this time, Mr. Naegele.' To which I responded: 'That remains to be seen!' I headed off to see Petr Uhl and Anna Šabatová, which was one of the main places where I always gathered information in Prague. Uhl had been the source of the news reports that a student had been killed in the protest two days previously. He was home alone but was just about to go out. We spoke briefly; he told me that he was beginning to think that he had been the target of a provocation; that there were three Martin Šmíds among registered university students in Prague and all of them were alive. He said he had to get this confirmed and issue a statement setting the record straight. He suggested that it would be best if we did not leave the building together. 'You go first,' he told me. I left, and I then later found out that the StB detained Uhl as he walked out of his building minutes after me. He was only released several days later.

As I was walking through the Vrchlický Gardens by the National Museum on my way back to the hotel, I ran into Stanislav Milota, the husband of Vlasta Chramostová. He was beaming: 'It's begun! Just wait until you see the size of the crowd on Wenceslas Square! The entire square is full, not just the area around the horse [the equestrian statue of Saint Wenceslas].' I made my way down the square and it really was packed. People were even standing or sitting on telephone booths. StB officers were just milling around, waiting for orders that never came. The crowd started moving via Můstek, along National Boulevard (Národní), crossing the river without hindrance, in contrast to previous protest marches when riot police had blocked the bridges. It was only when the crowd reached Újezd after dark that busloads of riot police arrived, encircling the demonstrators. A couple of other journalists and I ran up the slope precisely where Olbram Zoubek's memorial to the victims of communism is today, from where we had a good overview of the situation. Fortunately, the standoff was relatively brief, an agreement was reached between the police and the protest leaders, and the demonstrators were allowed to disperse peacefully. I then walked as far as the Lesser Town (Malostranské) Square, but it was not possible to get any further – the People's Militia (LM) and uniformed police (SNB) with dogs had blocked off access to Prague Castle.

I went back to my hotel and wrote a report that about 100,000 people had marched in that day's protest. The first edition of *Rudé právo* (communist party daily) on Monday, November 20, gave the number of demonstrators as 150,000, but the second edition gave the number as only 100,000. I suspect that they reduced their estimate after VOA's broadcast about the demonstration. Front pages of both editions were pinned up in shop windows on Wenceslas Square with the comment that *Rudé právo* lies. However, that was only the beginning. Every evening thereafter more and more protesters showed up, packing the square to bursting – by Friday there were perhaps as many as 400,000 people squeezed into the square and surrounding streets.

In my opinion, the turning-point was on Wednesday, November 22, when workers from the ČKD engineering works and other factories in the Vysočany district of Prague came into the centre.
Yes, Wednesday the 22nd was a turning-point, and this was not only a matter of the workers from ČKD, but also of the Czechoslovak army, which according to various reports was supposed to

take up positions around Prague, but which in the end did not intervene. On Wednesday, I was at the Faculty of Journalism, and there the students were clearly afraid. They requested a guarantee from commanders of the Czechoslovak People's Army that the soldiers would not intervene – otherwise they said they would not go to Wenceslas Square. But these students studying to become journalists at that time were largely the children of prominent Communists; they did not make a good impression on me at the time, in contrast for instance to the whole classes of enthusiastic high school students from Prague and elsewhere, as well as students from other university departments.

Also, on that same day Czechoslovak Television started to broadcast live from a large cherry-picker on Wenceslas Square, from which presenter Jiří Hrabovský reported on this and subsequent demonstrations. These live broadcasts were key for the revolution, but for me as a reporter there were pros and cons. On the positive side, from the technical point of view, I could record the speeches on Wenceslas Square directly from the television set in my hotel room in audio broadcast quality by plugging into the audio jack. Getting broadcast quality audio was otherwise impossible even on those occasions when I recorded from the Melantrich building from where the speakers addressed the crowd. I was prevented from setting up my microphone in advance on the balcony and of course I was barred from the balcony during the demonstration and had to sit in an anteroom.

How did you experience the November Revolution?

I was overloaded with work, with barely enough time to provide updates, background reports and interviews on developments. Much of my time was divided between the Magic Lantern Theatre where the Civic Forum had set up its headquarters and where it held news conferences every evening, and my hotel room, where I could monitor Czechoslovak television as well as the massive crowds which gathered late every afternoon that week in the square below.

And then suddenly on Friday night, the first time that due to an excess of work editing audio from that evening's mass rally on the square, I decided not go to the Magic Lantern for the Civic Forum news conference, Václav Havel and his interpreter Rita Klímová announced that the Communist leadership had just resigned. I was still filing reports when Wenceslas Square exploded in celebration. At first, I did not know what was going on. I switched on the TV and learned that the entire presidium of the Central Committee of the Czechoslovak Communist Party had tendered their resignations. I ran outside and conducted a few interviews with people who were dancing at the crossroads of Wenceslas Square and Vodičkova Street and went back to the hotel to file the story.

And this continued over the weekend. On Saturday morning Cardinal Tomášek led a mass celebrating the canonization of St. Agnes of Bohemia. The crowds at the castle around St. Vitus Cathedral were huge, and after the mass I had to decide on the spot whether to go to Letná hill, where an immense rally was to be held in the park since there was insufficient space in Wenceslas Square for the massive crowds that had been gathering there every evening, or else monitor the Letná rally on TV in my hotel room and file stories from there. I opted for the hotel, because everything was on television and I was able to record all the speeches in relative calm and deliver my reports on time. I should note that throughout the revolution the Voice of America did not send me any assistance: neither a producer, nor another journalist. Everybody had the feeling that I knew everything, that I had the language, the contacts, the area expertise and that therefore I could cope. But that meant I never left Prague to see how the revolution was faring

elsewhere. Nevertheless, I was able to interview activists from outside of Prague, including from Slovakia, whom I interviewed at the Magic Lantern.

Since the StB was essentially either paralyzed or too busy destroying its files to pay much attention to me, I started phoning some of my friends directly from the hotel, friends with whom I had not had any contact since I started at VOA five years previously, and some others whom I had not seen for far longer. Some friends simply showed up out of the blue, knocking on the door of my hotel room. It was a heady atmosphere, suddenly reconnecting without fear.

Did you feel a sense of satisfaction during those November days – for work performed, for the fact that you were there?
Yes, that the trials, tribulations, the fear and anxiety of the previous several years had not been in vain, that the revolution was peaceful, calm and dignified, that people could finally live without fear, speak their minds and travel to the West...

Was November 1989 the culmination of your journalistic career?
Yes, you can say that the end of 1989 was the culmination of my journalistic career. A further 13 years of journalistic work primarily on the territory of the former Yugoslavia and in the Soviet Union were extremely interesting, but without a happy ending.

What role did Václav Havel play in the entire matter? How did you see him then and how do you see him now with the benefit of hindsight?
Of all those in the opposition, he articulated things best; he was acknowledged abroad, and enjoyed respect in the journalistic community in spite of the fact that his English was less than perfect. Most importantly he was increasingly acknowledged at the time by large numbers of Czechs as a saviour, as the right person to lead the country. His opinions were well thought through, even though during the Velvet Revolution at times he appeared quite nervous. But his landmark New Year speech, after so many empty New Year speeches by President Gustáv Husák, constituted a very deep breath of fresh air, in which Havel described things as they really were, the true state of Czechoslovakia. His speech was electrifying, comprehensible, and it was cited and published in newspapers all over the world – without a smidgen of long-winded, vacuous filler.

As a journalist did you accompany him on his first foreign trips?
Yes, on the first working day of 1990, January 2, we flew in the presidential Ilyushin IL-62 to East Berlin for talks with the East German Prime Minister Modrow, from where we flew on later in the day to Munich. When we landed in Munich, Havel looked out of the airplane's window and was shocked that despite his expressed wish that this should be merely a working visit, a red carpet was being rolled out right up to the plane and a military band was on hand, as were West German Federal President von Weizsäcker, Federal Chancellor Kohl, Foreign Minister Genscher, the prime minister of Bavaria and crowds of reporters and TV cameras.

Why did this first meeting 'at the highest level' take place in Munich?
Havel met with his West German hosts in the building in which the Munich Agreement was signed in September 1938 [today it's home to the Hochschule für Musik und Theater]. Havel clearly wanted a symbolic gesture slightly over half a century after Hitler, Mussolini, Daladier

and Chamberlain signed away Czechoslovakia's sovereignty. When we got to the site of the meeting, there was a large crowd in front of the building to welcome Havel. Subsequently, von Weizsäcker came to Prague on 15th March 1990 on the anniversary of the Nazi occupation of Prague and the declaration of the Protectorate of Bohemia and Moravia. In my opinion, Havel's visit did more than merely open a new chapter in relations in central Europe, which since 1945 the communists had sought to keep divided – it was the beginning of the restoration of Czecho-slovakia's sovereignty, which culminated in the complete withdrawal of Soviet military forces from the country the following year..

Did you also fly with Havel to Washington?
Yes, his reception in Congress was rapturous; triumphant. He received a similar welcome in New York and in Canada, in Ottawa and Toronto. I also covered his trip to Moscow to meet Gorbachev at the Kremlin.

At this time the American administration did not even consider an expansion of NATO to the East. In your opinion, what role did Havel play in the fact that in the end this expansion happened?
I do not know the details. In any case this only happened during Clinton's time in the White House. Havel had been friends with George Bush senior – they got along well and Bush came to Prague for the first anniversary of the Velvet Revolution – but Bush, though experienced, was quite cautious in foreign affairs. In contrast, Clinton did not come from the foreign policy branch. Before becoming president, he had been governor of Arkansas. For foreign policy matters he relied on Madeleine Albright, and she certainly consulted with Havel. But many other people also played a role in NATO's expansion, for instance Lech Wałęsa and others in the Solidarity movement.

From being in the centre of events in 1990, it is as though at the beginning of 2018 we have once again become a province that is not capable of seeing beyond the end of its own nose. What is happening with this state and this society, through which such favourable winds were blowing in 1990?
I would counter: What is happening in the Western world? In the America of Donald Trump? What has happened to Great Britain that 52% of Britons voted to leave the EU?

Are we witnessing a general crisis of liberal democracy?
Yes. And there are various reasons for this. On the one hand, there is the party system, which is over 200 years old and no longer seems to be functioning as it was intended, proving incapable of adequately reacting to the new situation and of successfully countering populism. Similarly, mainstream media have also been losing readers, viewers and listeners for a long time. So, two fundamental democratic institutions are in crisis. How large, or rather small, a percentage of people draw verified reports from the newspapers, and what percentage download reports from the ether of free-flowing information without any coherent structure or context, to which so-called serious media is also of course adapting itself in order to survive? The opinions of perhaps a majority of people are formed by a quite superficial, distorted or deliberately manipulated depiction of the world, and there a lot of things that people are not even aware of.

You have in mind social networks...
Yes.

The question is how, in this state of affairs, free elections, for instance, can fulfil their purpose, when a foreign third party intervenes in them and discredits them by manipulating public opinion, as happened in the case of Brexit or the American presidential election.

What can be done about this? Is it just going to get worse? Why is there such a swing to the right today, to populism, anti-Semitism, intolerance, manipulation of voters regarding migrants and refugees. The blame for everything is shifted onto international organizations and liberal democratic parties. But international organizations function the way their member states want, and if I want to achieve something at the international level, then I have to cooperate, discuss and negotiate rather than insisting: either my way or no way.

As a journalist you have been dependent for your whole life on the free dissemination of information – today it paradoxically seems that the greatest danger for civic freedoms, including freedom of expression, is the free dissemination of reports which in reality are not reports, and of information that is not information...

Among other things, this is a result of an emphasis on technology and insufficient education in social and civic affairs... Throughout elementary and high school in New York, we had a course known as social studies, which included history, geography and civic education. The focus was on gaining a fundamental understanding of the world around us, for instance how our home-town and state function, the importance of regular, free, fair and democratic elections, our ethnic and religious diversity and so on... However, during my studies of the countries which constituted the Soviet bloc, including Czechoslovakia, I encountered a constricted flow of useful information from official East European media outlets. A lot of things were either taboo, distorted or senselessly shortened. Whoever had information, also had power. I was conscious of this at least from the moment of Husák's reaction to my commentary.

Western civilization, civilization as such, is founded on information which is structured – this information is a product of an extensive educational process, the continuity of which stretches back through mediaeval universities to ancient Greece and the Orient. Does the mass social propagation of lies, conspiracy theories and disinformation that is being freely spread over social networks have the potential to completely disintegrate civilization?

The potential for such a disintegration of civilization certainly exists. Democracy is fragile after all. As long as a large portion of voters in any given democratic state remain indifferent to its development, do not participate in elections, or succumb to cheap populist arguments of politicians who subordinate absolutely everything – in particular the real interests and needs of a majority of the inhabitants of a particular country – to their greed for power and money, then our civilization really will suffer and possibly even disintegrate. In all likelihood things will get even worse before a change for the better comes. As we know from experience, there is no going back to the past; slogans like 'Let's make America great again' or in the case of the referendum on Brexit 'Take back control' are totally misleading. We cannot turn back the clock.

Interview with Petr Placák for *Babylon* revue,
Cafe Louvre, Prague, March 6 and 18, 2018;
re-edited by Jolyon Naegele for republication in August 2019

PHOTOGRAPHS

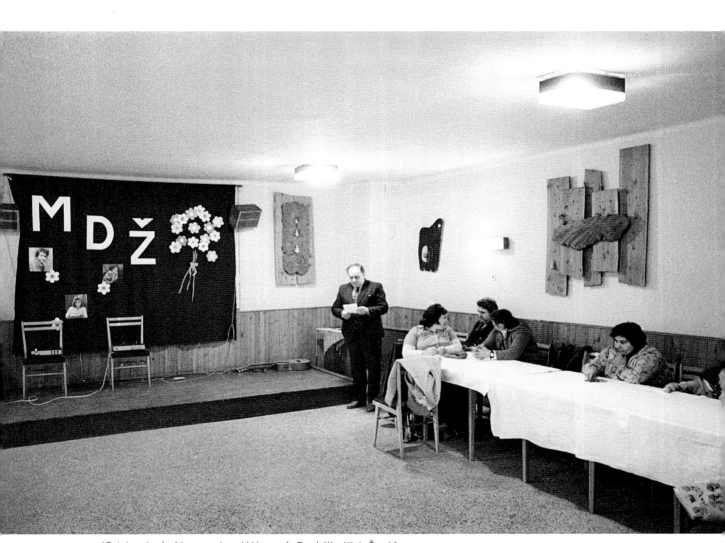

'Celebration' of International Women's Day' (Jindřich Štreit)

/95

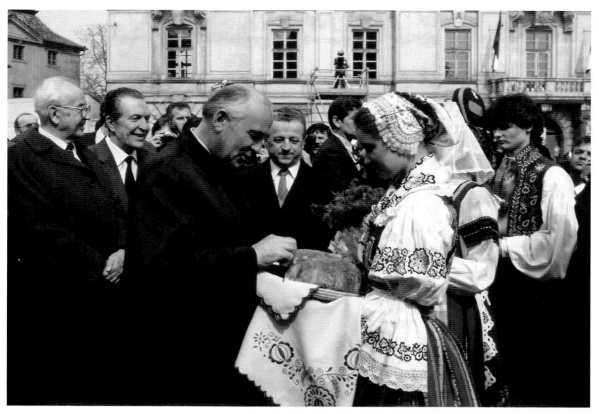

Mikhail Gorbachev is welcomed with bread and salt at Hradčany Square in Prague, 9. 4. 1987.
(ČTK / Karel Mevald)

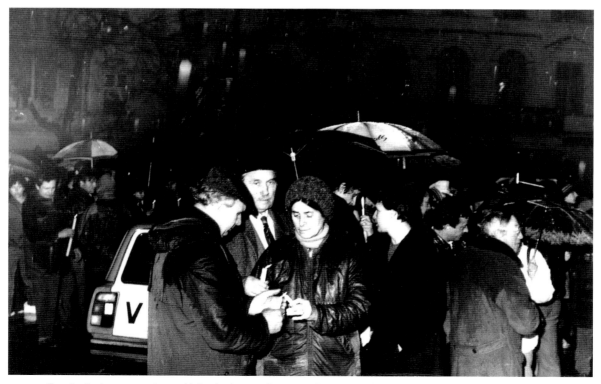

Candle-lit demonstration at Hviezdoslavovo Square in Bratislava, 25. 3. 1988

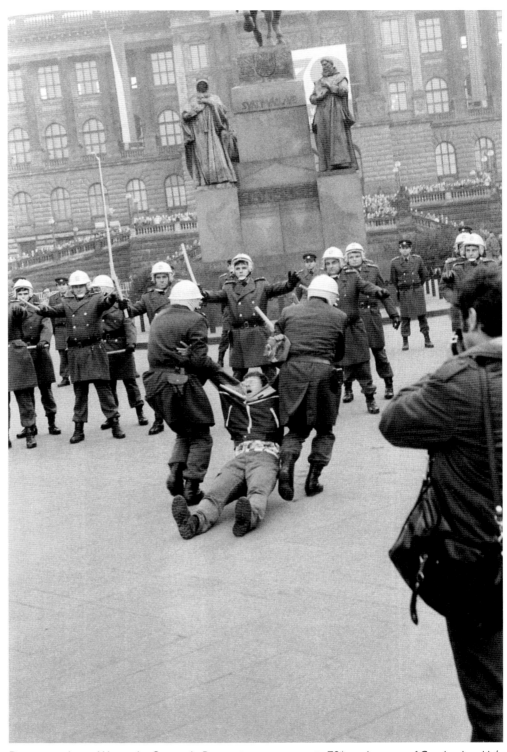

Demonstration at Wenceslas Square in Prague to commemorate 70th anniversary of Czechoslovakia's foundation, 28. 10. 1988 (ČTK / Petr Josek)

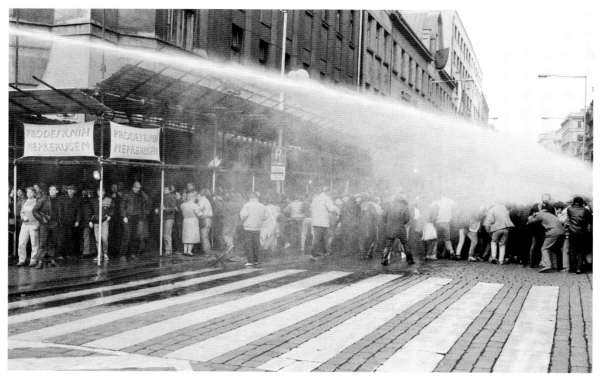

Demonstration on occasion of the 70th anniversary of Czechoslovakia's foundation, water cannon in Opletalova Street, 28. 10. 1988 (ČTK)

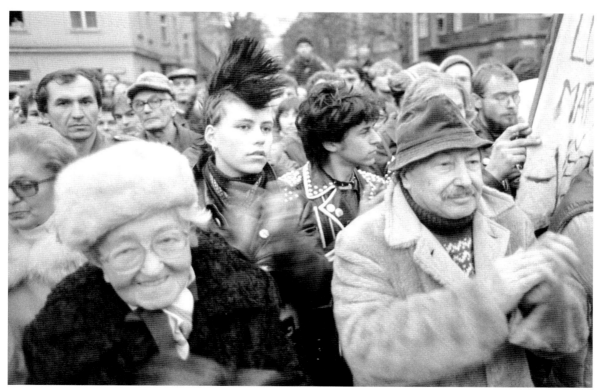

Demonstration on Škroupovo Square in Prague, at which representatives of independent initiatives gathered to commemorate anniversary of the Universal Declaration of Human Rights. The demonstration was permitted thanks to the official visit by French President François Mitterrand, who also supported the Czechoslovak opposition by inviting them to a breakfast at the French Embassy in Palais Buquoy, thus becoming the first foreign statesman to grant official recognition to the opposition, 10. 12. 1988. (ČTK / Stanislav Peška)

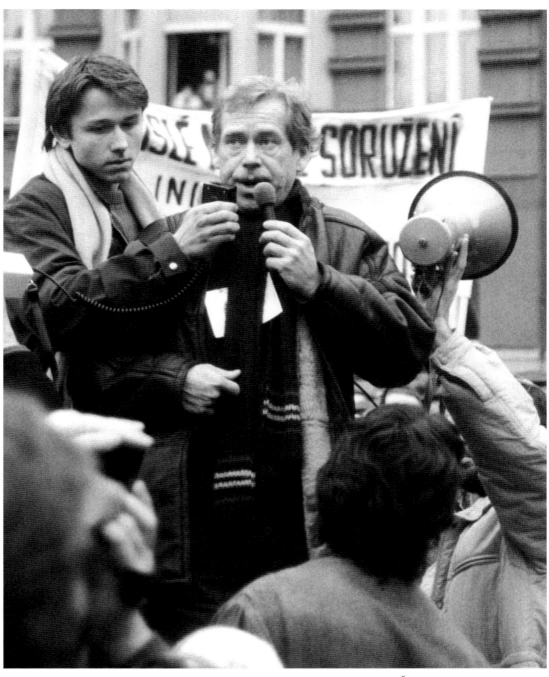

Dramatist and Charter 77 signatory Václav Havel speaking at demonstration on Škroupovo Square in Prague, 10. 12. 1988 (ČTK / Stanislav Peška)

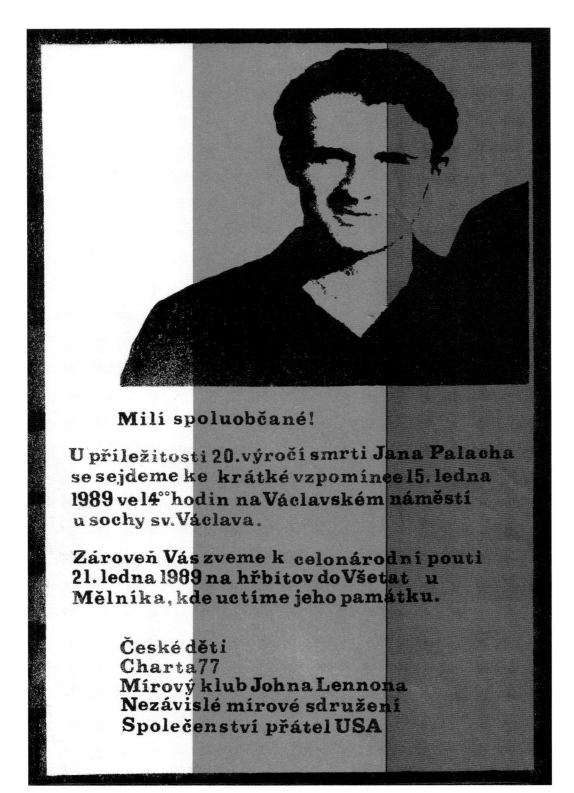

Milí spoluobčané!

U příležitosti 20. výročí smrti Jana Palacha se sejdeme ke krátké vzpomínce 15. ledna 1989 ve 14°°hodin na Václavském náměstí u sochy sv. Václava.

Zároveň Vás zveme k celonárodní pouti 21. ledna 1989 na hřbitov do Všetat u Mělníka, kde uctíme jeho památku.

České děti
Charta 77
Mírový klub Johna Lennona
Nezávislé mírové sdružení
Společenství přátel USA

Invitation of independent initiatives to pay tribute to the memory of Jan Palach in January 1989

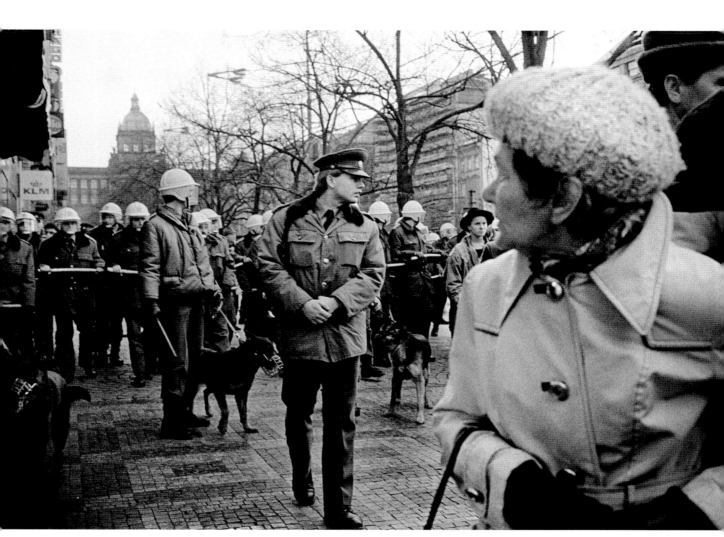

Palach week, demonstration on Wenceslas Square, January 1989 (Lubomír Kotek)

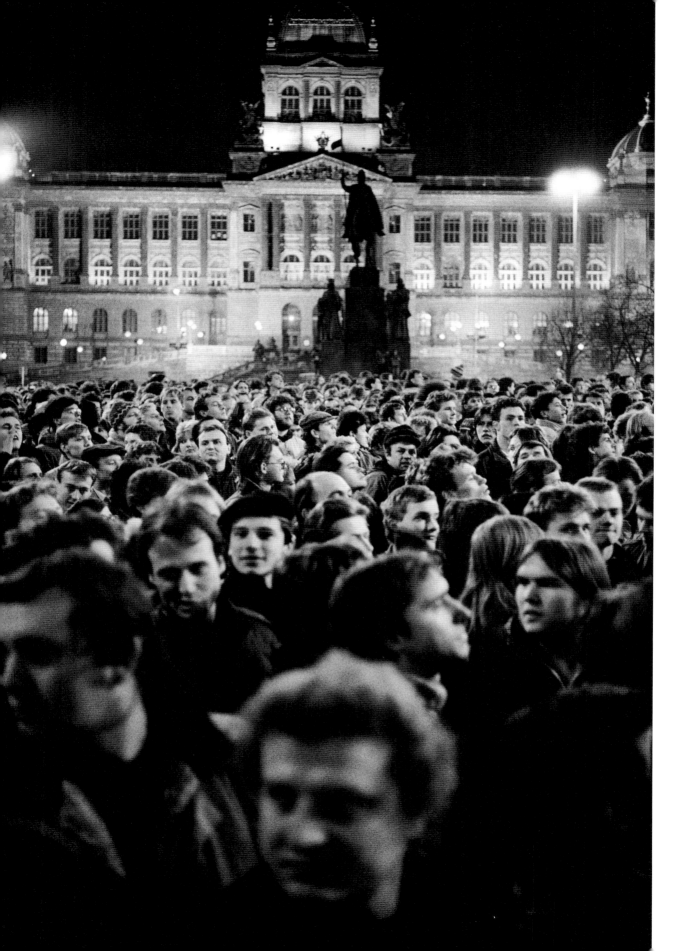

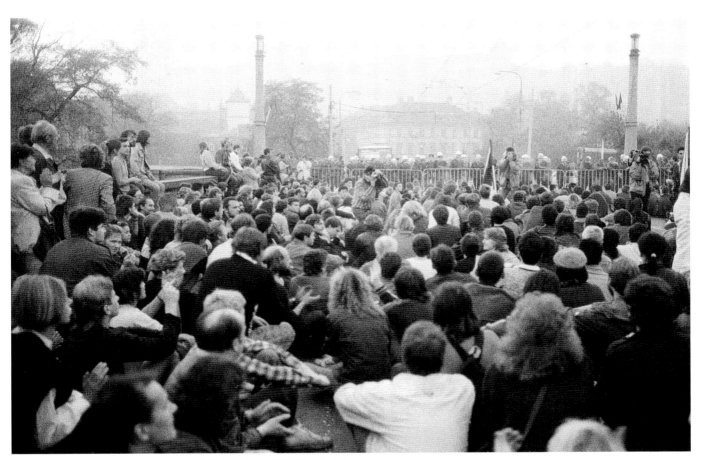

Demonstration on 28th October 1989 (Ota Pajer)

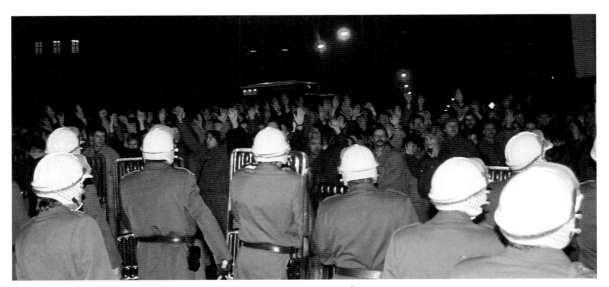

Three-day demonstration for clean air in Teplice, 11.–13. 11. 1989 (ČTK / Miroslav Rada)

← Palach week, demonstration on Wenceslas Square, January 1989 (Lubomír Kotek)

Canonization of St. Agnes of Bohemia at St. Peter's Cathedral in the Vatican, 12. 11. 1989 (ČTK)

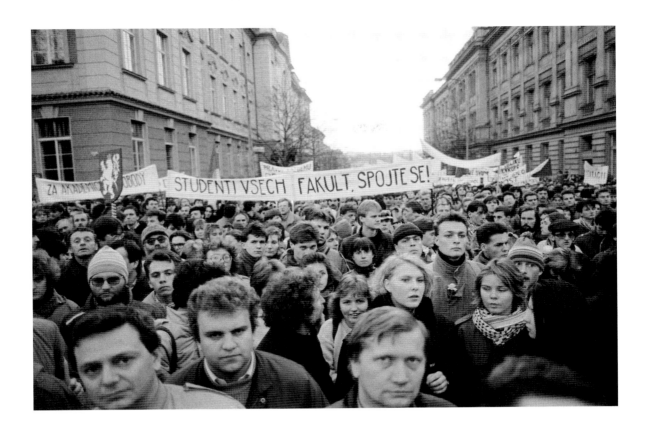

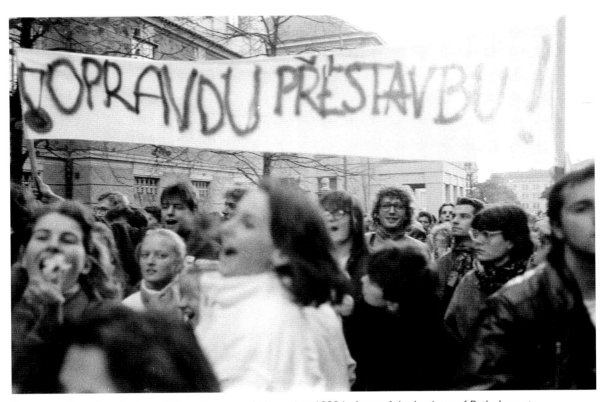

Demonstration of students on 50th anniversary of November 1939 in front of the Institute of Pathology at Albertov, 17. 11. 1989 (ČTK – upper photo, Ota Pajer – lower photo). Slogan on banners: 'Students of All Faculties Unite' and 'Real Perestroika'.

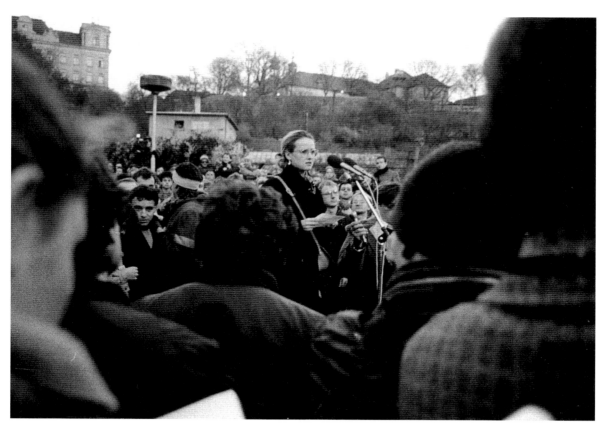

Speech by Monika Pajerová on social dialogue, which started the student assembly at Albertov, 17. 11. 1989 at 4 p.m.

Monika Pajerová and academic Miroslav Katětov, who was the next speaker.

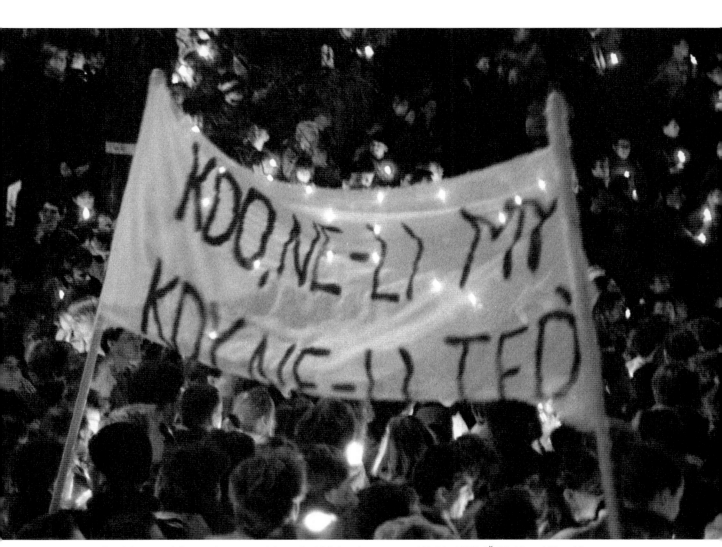

Participants of the student assembly at the Vyšehrad cemetery, 17. 11. 1989 (ČTK / Pavel Hroch).
Slogan on banner: 'Who, If Not Us. When, If Not Now'.

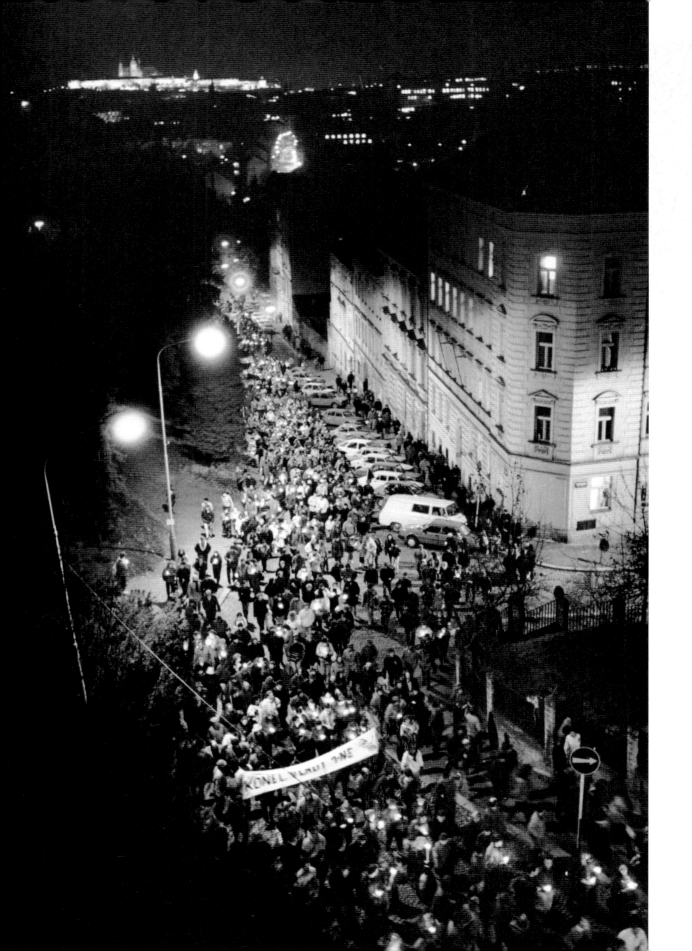

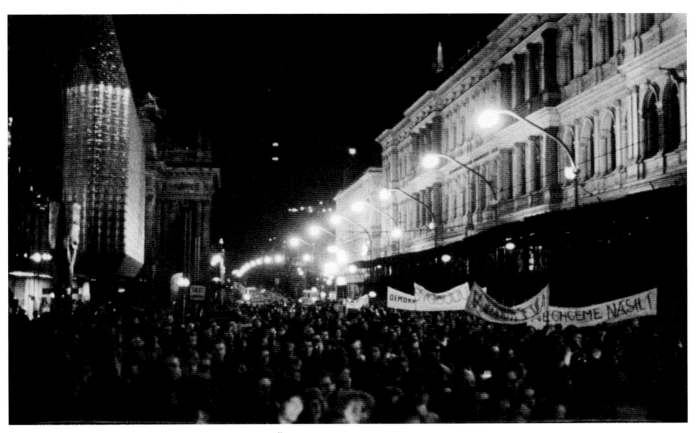

National Boulevard, 17. 11. 1989 (ČTK)

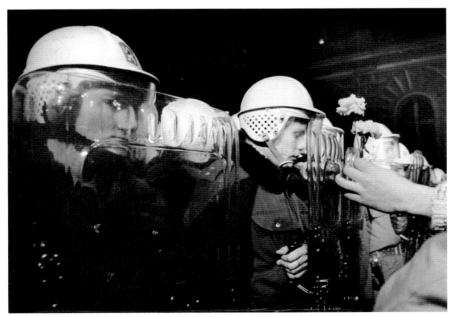

National Boulevard, 17. 11. 1989 (Pavel Štecha)

← March of students, 17. 11. 1989 (Pavel Štecha)

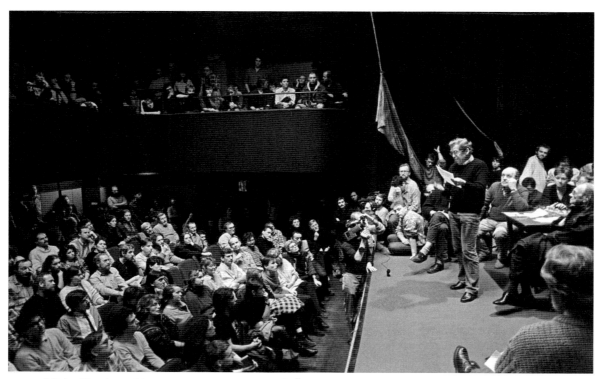

Václav Havel speaking at an assembly at Prague's Činoherní Klub Theatre, where a group of intellectuals, artists and students formed Civic Forum, a broad platform of all civic activities aimed at renewing political pluralism and rejecting the totalitarian communist regime, 19. 11. 1989 (Petr Mazanec / ČTK)

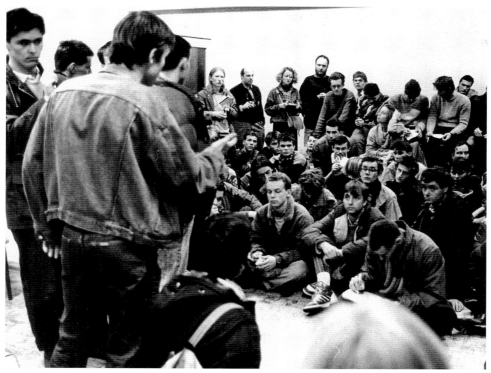

Organization of university strike committees according to individual faculties in the underground drying room of the Hvězda student dormitory

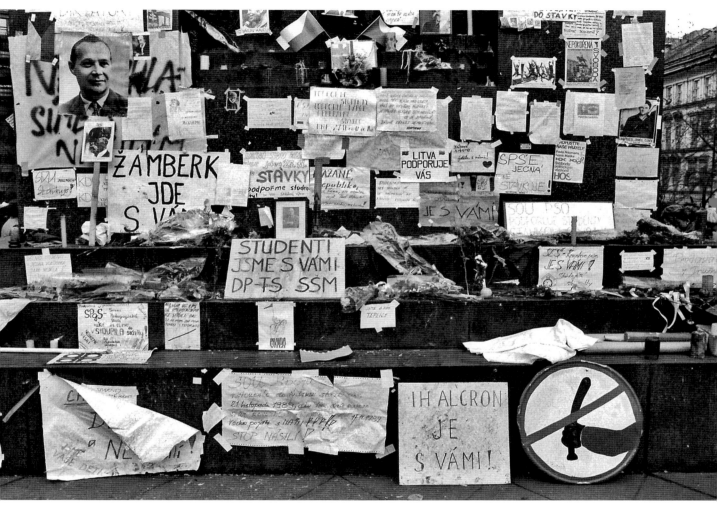

Pedestal of the statue of St. Wenceslas on day of the declaration of occupation strike of universities, 20. 11. 1989 (ČTK / Jaromír Čejka)

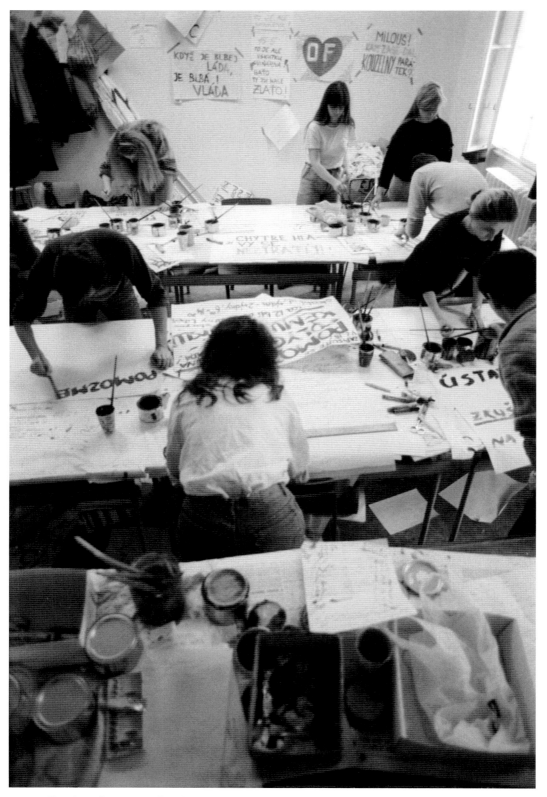

Creation of posters at Faculty of Arts, Charles University, in the so-called painting room, at the beginning of December 1989. Slogan 'If Láďa (Ladislav) Is Stupid, Then Government Is Stupid Too' (on wall) is a reaction to appointment of new government led by Ladislav Adamec, in which the Communists had a majority. (Charles University archive / Jan Jindra)

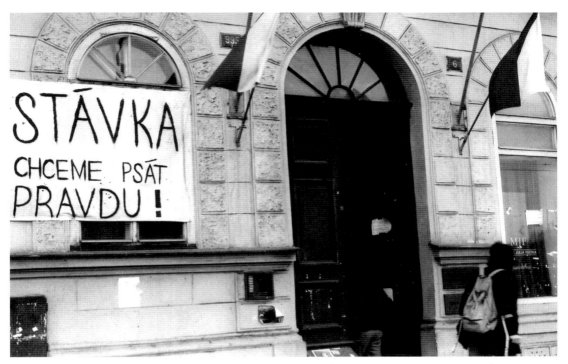

Strike, Journalism Faculty, Charles University. Slogan on banner: 'Strike. We Want To Write Truth'.

Coordination centre of striking university students, Monika Pajerová and Martin Mejstřík, building of Theatre Faculty at Academy of Performing Arts in Řetězová Street (Ota Pajer)

Press conference of striking students at DISK Theatre

Jiří Dienstbier and Monika Pajerová at first joint press conference of striking university students and Civic Forum at Magic Lantern Theatre

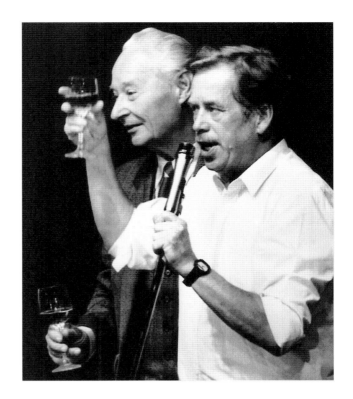

Václav Havel with Alexander Dubček celebrating in reaction to the announcement on Czechoslovak TV that the Communist Party Central Committee has stepped down, 24. 11. 1989. (ČTK / AP / Dusan Vranic)

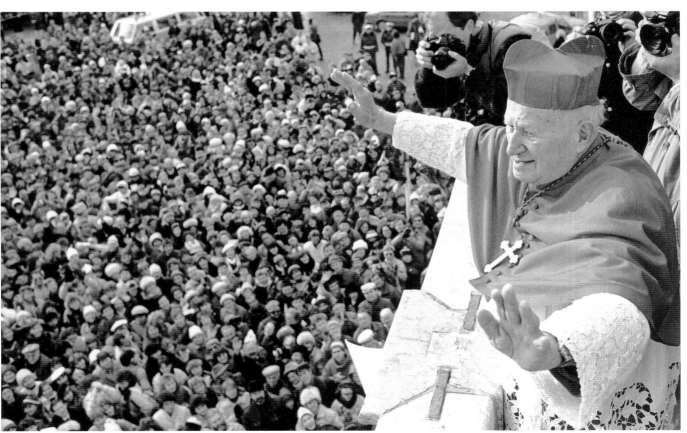

Cardinal František Tomášek, celebration of canonization of St. Agnes of Bohemia, Prague Castle 25. 11. 1989 (Pavel Štecha)

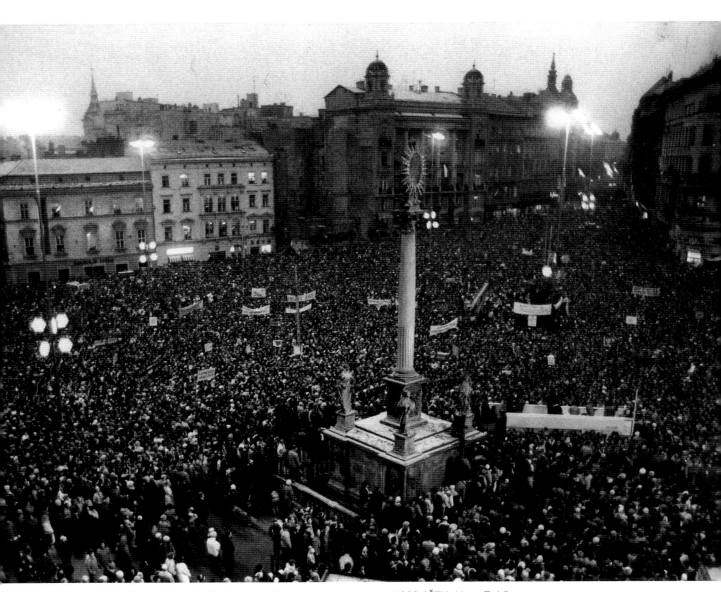

Freedom Square (Náměstí Svobody) in Brno during November 1989 (ČTK / Igor Zehl)

Meeting of representatives of Polish Solidarity and representatives of Civic Forum from Prague, Brno and Ostrava at Czechoslovak-Polish border in Český Těšín (Cieszyn). Jaroslav Šabata (right) welcomes Adam Michnik, 21. 12. 1989. (ČTK / Petr Berger)

Alexander Dubček, symbol of Prague Spring in 1968, Václav Havel and Ladislav Adamec, head of the Czechoslovak Federal Government, on platform during demonstration at Letná hill in Prague, attended by more than half a million people in support of Civic Forum's opinions on the country's internal political situation and the possibilities for resolving it. (ČTK)

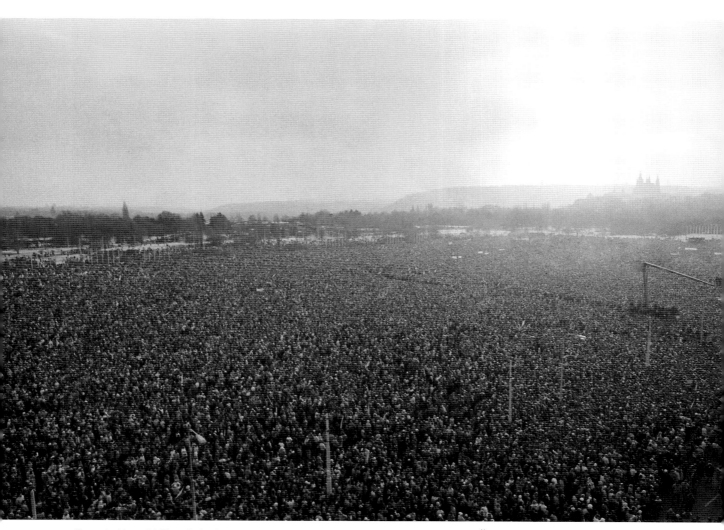

Crowded Letná hill park during demonstration on 25th and 26th November 1989 (ČTK)

On 27th November a two-hour general strike took place over the whole of Czechoslovakia. Assembly of mothers and children on Prague's Old Town Square. (ČTK)

Portrait of first Communist President Klement Gottwald is removed from the power station in Třebovice district of Ostrava, 27. 11. 1989.
(ČTK / Vladislav Jasiok)

Workers and technicians of Škoda engineering works in Plzeň leaving for demonstration on Republic Square as part of general strike, 27. 11. 1989 (ČTK / Jiří Berger)

Karel Urbánek, general secretary of Communist Party Central Committee, Prague, 27. 11. 1989

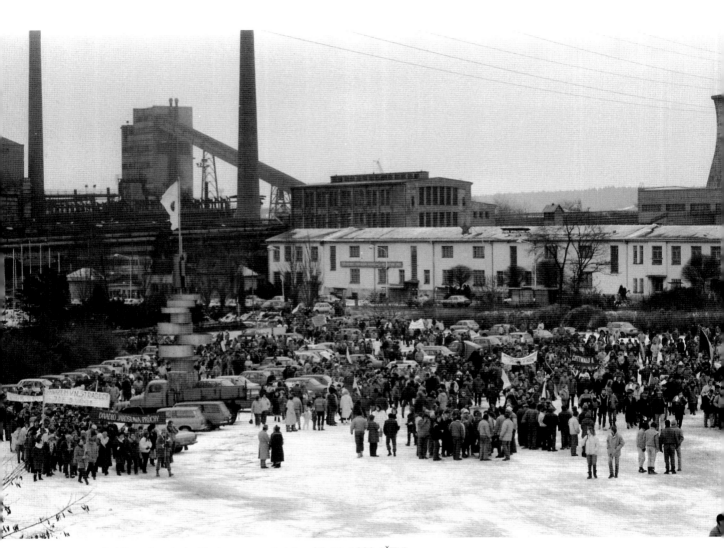

Poldi steelworks in Kladno, general strike, 27. 11. 1989 (ČTK)

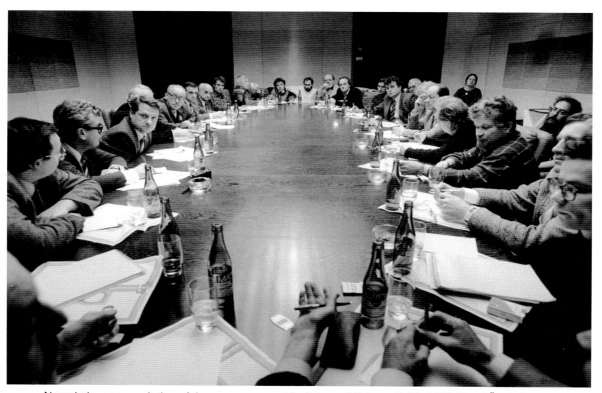

Negotiations on resolution of the government crisis, Palace of Culture, 8. 12. 1989 (Pavel Štecha)

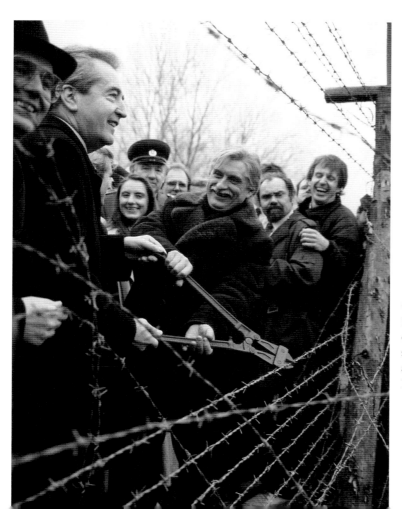

Czechoslovak Foreign minister Jiří Dienstbier (middle) and Austrian counterpart Alois Mock (left) symbolically cut barbed wire at Hatě-Kleinhaugsdorf state border, 17. 12. 1989. (ČTK/ Vít Korčák)

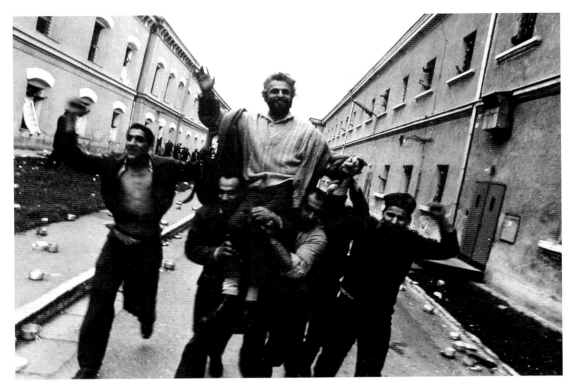

Fedor Gál, representative of the Society Against Violence (Slovak equivalent of Civic Forum), carried
by prisoners from Leopoldov (Tibor Huszár)

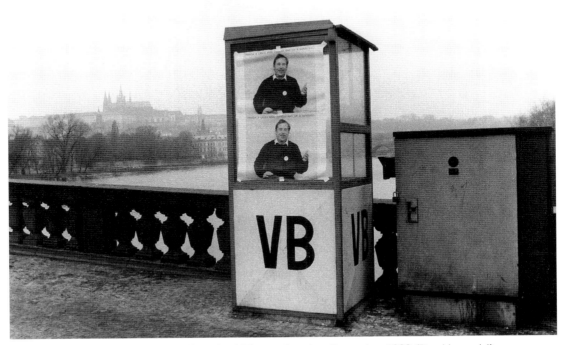

Posters with Václav Havel on Public Security (VB) guard station, December 1989 (Pavel Jasanský)

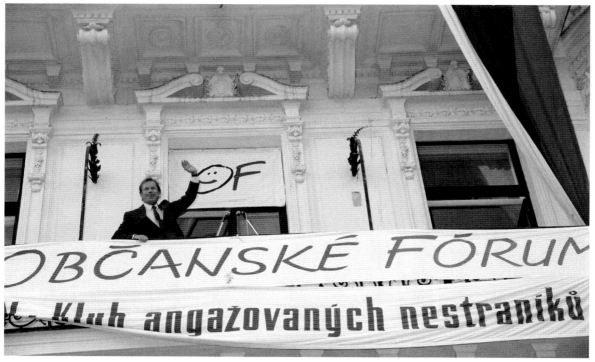

Václav Havel announces candidacy for Czechoslovak president (Alan Pajer)

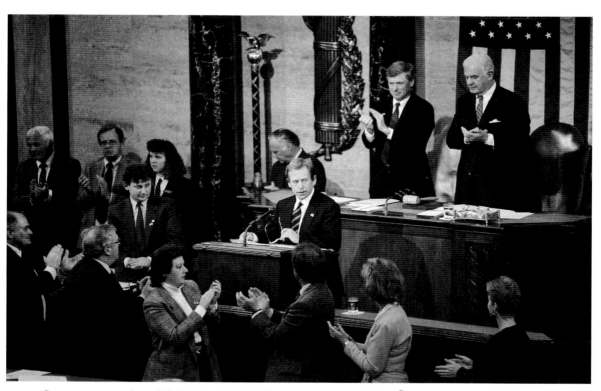

Rapturous reception of Václav Havel in U.S. Congress, February 1990 (ČTK / Jaroslav Hejzlar)

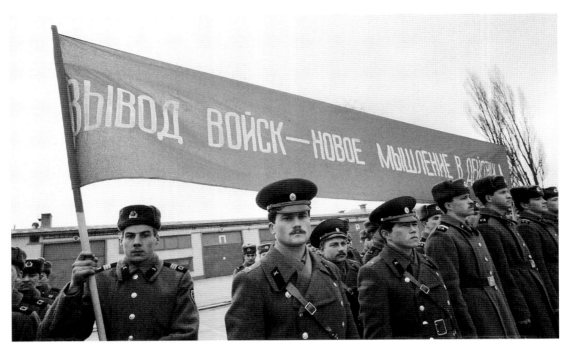

Ceremonial muster of Soviet troops under banner 'Departure of Troops – New Thinking in Praxis',
Frenštát pod Radhoštěm, 26. 2. 1990 (ČTK / Petr Berger)

Michael Kocáb (second from right), deputy chair of Federal Assembly's supervisory commission
for withdrawal of Soviet troops from Czechoslovakia, accompanied by representatives of Czechoslovak
and Soviet armies, local politicians, Civic Forum, inspects military facilities in Bruntál, April 1990.
(ČTK / Vladislav Galgonek)

The Rolling Stones with Václav Havel at Prague Castle, August 1990 (Alan Pajer)

Visit by Pope John Paul II to Prague, 27. 4. 1997 (Alan Pajer)

Václav Havel dancing with the Clintons at White House, 17. 9. 1998 (Alan Pajer)

Václav Havel with the Dalai Lama, 4. 10. 1998 (Alan Pajer)

Participants of 'Vote for NATO' demonstration express their support for joining NATO by signing petition initiated by artists and students on day when issue was debated by Czech Chamber of Deputies, Hradčany Square in Prague, 14. 4. 1998. (ČTK / Tomáš Železný)

Around 2,000 people watching concert held at Hradčany Square on the evening of 14th June 2003 to celebrate positive result of referendum on Czech Republic's joining the EU. (ČTK / Michal Krumphanzl)

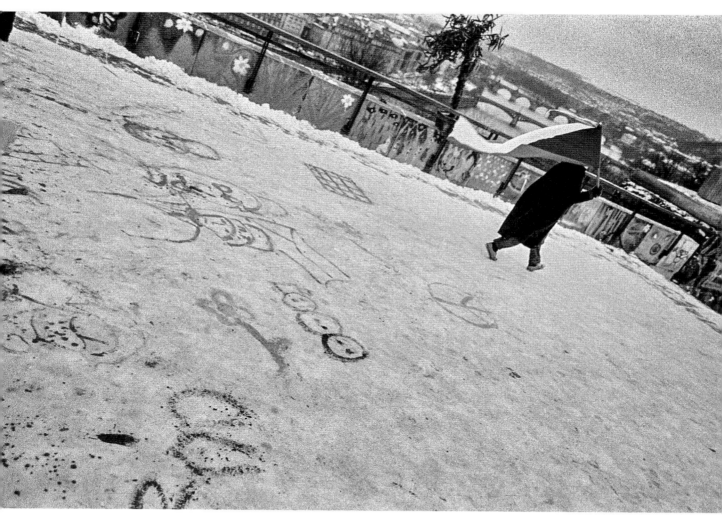

Demonstrator leaving Prague's Letná hill, 26. 11. 1989 (Jan Šilpoch)

THE PATH TO NOVEMBER 1989
CHRONOLOGICAL OVERVIEW

11. 3. 1985 Mikhail Gorbachev elected general secretary of the Central Committee of the Communist Party of the Soviet Union.

29. 5. 1985 General Assembly of the Czechoslovak Socialist Republic (ČSSR) elects Gustáv Husák president (for the third time).

7. 7. 1985 Roughly 100,000 believers, led by the entire church hierarchy, gather for the traditional pilgrimage at Velehrad in Moravia on the 1,100th anniversary of the death of St. Methodius. The official speeches by the minister of culture and the district secretary, interpreting the gathering as a 'peace assembly', are whistled down by the believers, who chant calls for real religious freedom.

14. 11. 1985 Charter 77 publishes document drawing attention to the adverse state of the centralized Czechoslovak economy and asserting the need for reforms.

19. – 21. 11. 1985 Soviet leader Mikhail Gorbachev and US President Ronald Reagan meet for the first time in Geneva.

22. 1. 1986 Václav Havel awarded Erasmus of Rotterdam prize for his contribution to maintaining European culture.

24. – 28. 3. 1986 17th congress of the Czechoslovak Communist Party (KSČ) held in Prague, which confirms all hitherto functionaries in the KSČ leadership in their posts and approves the direction of country's social and economic development, emphasizing the need for the implementation of scientific-technological progress.

26. 4. 1986 Accident at the Soviet atomic power station in Chernobyl with consequent explosion and escape of radioactive materials. The Czechoslovak public is only officially informed on 29. 4. in the evening. However, the amount of information is substantially less than in surrounding states.

23. – 24. 5. 1986 Parliamentary elections held in Czechoslovakia according to the traditional scenario: 99.9% votes of 99.4% registered voters are for the chosen candidates of the National Front (consisting of candidates from the Communist Party and other associated and authorized parties).

20. 11. 1986 Committee for the Defence of the Unjustly Persecuted (VONS) publishes a communication summarizing the almost 600 cases that it has recorded since its foundation in 1978 and about which it has informed.

6. 1. 1987 Charter 77 in its document *A Word to Our Fellow Citizens* appeals for civic activity and the truthful naming of problems and their causes in everyday life and work.

23. 3. 1987 Charter 77 in a letter to Mikhail Gorbachev calls for the withdrawal of Soviet troops and nuclear warheads from the territory of Czechoslovakia.

8. – 11. 4. 1987 On his first visit to Czechoslovakia as party leader, Mikhail Gorbachev expresses support for the KSČ leadership and its 'normalization' policy.

30. 4. 1987 In its document *So That We Can Breathe* Charter 77 points out the catastrophic state of the natural environment in Czechoslovakia and the possibility for its improvement.

29. 11. 1987 *Joint Pastoral Letter of Bishops and Administrators of Czech and Moravian Dioceses on the Occasion of the Year of the Beatified Agnes of Bohemia* is read out in churches. The letter, which starts with the words 'Straighten Up and Lift Up Your Heads', starts the Decade of Spiritual Renewal. At the same time Catholic layman Augustin Navrátil initiates a petition, *Catholic Initiatives For Resolving Situation of Believers in ČSSR*, which contains 31 problematic areas including religious freedom and the separation of church and state. The petition is also publicly supported by Cardinal Tomášek; in the following months it is signed by roughly 600,000 people.

10. 12. 1987 Around 2,000 citizens assemble at Prague's Old Town Square to demonstrate on the occasion of Human Rights Day. The event is monitored by several hundred uniformed and also plainclothes members of the security services, who intervene selectively and take away individuals for interrogation.

17. – 18. 12. 1987 At a meeting of the Communist Party Central Committee Gustáv Husák resigns as KSČ general secretary, and on his proposal Miloš Jakeš is elected to replace him.

11. – 12. 1. 1988 Communist Party General Secretary Miloš Jakeš visits the Soviet Union. At a meeting with him, Mikhail Gorbachev expresses support for the stance of Czechoslovak Communist Party not to re-evaluate the events and actors of the Prague Spring of 1968.

From January 1988 Publication begins of an independent monthly newspaper, *Lidové noviny*; it becomes one of the most widely distributed samizdat periodicals.

13. 2. 1988 Society of Friends of the USA (SPUSA) established as an informal civic initiative.

6. 3. 1988 Around 8,000 believers take part in pilgrimage mass in honour of the beatification of St. Agnes of Bohemia in Prague's St. Vitus Cathedral. After the mass, several hundred participants of the mass demonstrate in front of the archbishop's palace for religious freedom and the separation of church and state.

25. 3. 1988 Good Friday candle-lit demonstration for religious freedom and respect for human rights by Czechoslovak Catholics and university students takes place on Hviezdoslavovo Square in Bratislava. The security services disperse the assembled citizens using truncheons and water cannons.

11. – 14. 4. 1988 President Gustáv Husák pays official visit to the Soviet Union. On this occasion, Mikhail Gorbachev reiterates his insistence that the official evaluation of the events of 1968 and the correctness of the policy pursued by Husák's leadership in the following 'normalization' period remains unchanged.

16. 4. 1988 Independent Peace Association-Initiative for the Demilitarization of Society publishes its first declaration.

26. 4. 1988 Human rights defender Pavel Wonka dies, aged 35, in prison in Hradec Králové – the victim of unlawful court and prison practices.

10. 5. 1988 The Communist Party Central Committee sends a letter to all local party organizations warning against the 'activation of forces of the internal and external enemy'. (This was the first document after many years in which the Communist Party presidency appealed to the entire party.)

28. 5. 1988 Newly established independent initiative Czech Children (České děti) publishes its manifesto. It declares its allegiance to royalist and Christian values and the traditions of the Czech Kingdom.

11. 6. 1988 For the first time in more than 15 years, new Catholic bishops are ordained in Czechoslovakia – Jan Lebeda and Antonín Liška in Prague, and Ján Sokol one day later in Trnava.

21. 8. 1988 Demonstration takes place on Wenceslas Square in Prague on the occasion of the 20th anniversary of the intervention by troops of the Warsaw Pact. The security services brutally disperse

the crowd. More than 100 citizens are detained, some are brutally beaten and criminal proceedings are started against 13 of them.

8. 10. 1988 The Social Defense Initiative established with the aim of defending citizens against political, religious or other discrimination in the social field and of intervening at public offices and organizations on behalf of people thus afflicted.

10. 10. 1988 Federal Government headed by Lubomír Štrougal submits its resignation. President Husák immediately appoints new government, led by Ladislav Adamec.

15. 10. 1988 Independent initiative Movement for Civic Freedom (HOS) established. It publishes its political orientation in manifesto *Democracy for Everyone*.

28. 10. 1988 Demonstration held on Prague's Wenceslas Square to mark 70th anniversary of foundation of the Czechoslovak Republic. The security services brutally disperse the crowd with the use of truncheons and water cannon and the deployment of armoured personnel carriers and police dogs. Almost 500 people have their documents checked, 133 citizens are temporarily detained and criminal proceedings are initiated against 29 participants. Within the framework of so-called preventative measures, around 140 pro-democracy activists are imprisoned and so-called cautionary interviews are conducted with hundreds of others.

5. 11. 1988 Czechoslovak Helsinki Committee founded in Prague, which sets as its aim support for the Helsinki Accords (the Final Act of the Conference on Security and Cooperation in Europe of 1. 8. 1975 and subsequent documents). Jiří Hájek becomes its head.

11. – 13. 11. 1988 Independent initiatives organize the Czechoslovak 88 international symposium, which examines the landmarks in Czechoslovak history represented by the years 1918, 1938, 1948, 1968. The StB intervenes in a bid to prevent the event from being held. This results in extensive foreign media coverage and also protests from several European governments. The StB detains Václav Havel as he opens the meeting and disperses the other participants.

30. 11. 1988 The Soviet Union ceases to jam signals of Radio Free Europe/Radio Liberty, Deutschlandfunk radio stations. In line with this decision Czechoslovakia ceases blocking Radio Free Europe on 10. 12. 1988.

1. 12. 1988 An independent association, the John Lennon Peace Club, is established in Prague, which aims to be active primarily in the cultural field.

10. 12. 1988 An officially sanctioned gathering is held on Prague's Škroupovo Square on the occasion of International Human Rights Day. At the event several thousand citizens listen to speeches by representatives of independent initiatives; some of them then sign a resolution demanding the release of political prisoners, bringing the Czechoslovak legal order into accord with international pacts on human rights, the initiation of dialogue with the churches and discussion about a new constitution. In the course of December 1988 the East European Information Agency is established, functioning through cooperation between independent publicists in Czechoslovakia, the Soviet Union, Hungary and Poland. Its representatives in Czechoslovakia are Petr Uhl, Jan Urban and Petr Pospíchal.

15. – 21. 1. 1989 The so-called Palach week takes place. On the same day that OSCE approves concluding document in Vienna binding signatory states even more strictly to respect human rights and civic freedoms, 3,500 members of the security forces and the People's Militias close off Wenceslas Square in order to prevent a gathering to commemorate the 20th anniversary of Jan Palach's self-immolation. A lively anti-regime demonstration in the surrounding streets is subsequently brutally suppressed, 117 citizens are arrested and the party-controlled media launch a disinformation campaign. Over the next few days spontaneous small protest meetings take place, against which

special security forces and the People's Militia brutally intervene, using truncheons, dogs and water cannons. More than 350 people have their documents checked, are detained for questioning or are transported out of Prague; representatives of independent initiatives are arrested. Events culminate on 21. 1. with attempts to visit Jan Palach's grave in Všetaty. However, the security services prevent a commemorative act of remembrance at the grave. During February and March a range of repressive operations take place as a consequence of Palach week: interrogations, house searches, detentions, and politically motivated trials.

18. 4. 1989　During a visit by Czechoslovak Communist Party head Miloš Jakeš to Moscow, Mikhail Gorbachev supports the KSČ leadership in its stance not to re-evaluate the year 1968 and to retain the validity of the document approved at the conclusion of 13th KSČ congress *Lessons from Crisis Development in the Party and Society*.

1. 5. 1989　In spite of 'preventative' interviews and intimidation of selected representatives of independent initiatives and also a transfer of the official 1st May celebrations from Letna Hill park to Wenceslas Square, a group of citizens gather in the the upper part of the square where they unfold a banner demanding the release of political prisoners. State security forces force them out of the square and transport them by bus away from the city centre. Then the security forces savagely intervene against a group demonstrating in the centre of the square. A total of 113 people are detained; criminal proceedings are initiated against eight of them.

19. 6. 1989　Walk for Human Rights, organized by independent initiatives, takes place in Prague's pedestrian zone to express the participants' dissatisfaction with the state of human rights in Czechoslovakia.

29. 6. 1989　Radio Free Europe/Radio Liberty, VOA and other foreign media publish the *Several Sentences* open petition, which demands the release of political prisoners, unrestricted freedom of assembly, the legalization of independent initiatives, independent media providing objective information, care for the natural environment and a free discussion on the post-war history of Czechoslovakia.

21. 8. 1989　Several thousand people gather at Wenceslas Square in the early evening to commemorate the military intervention in August 1968. They chant slogans in support of independent initiatives, human rights and democratic developments in Hungary and Poland. Security forces forcibly disperse the protest.

From the middle of August 1989　Growing numbers of citizens of the German Democratic Republic gather in the garden of the Prague embassy of the German Federal Republic. The exodus of East German citizens continues in September and October and, according to official data, up until 8th November around 42,000 of them travel through Czechoslovakia.

25. 10. 1989　Around 200 citizens gather in Prague's pedestrian zone in order to protest against the introduction of a 100 crown banknote featuring a portrait of Klement Gottwald. The riot squad unit of the National Security Corps (SNB) disperses the gathering, bringing in 91 activists for questioning and temporarily detaining two activists.

28. 10. 1989　State security units violently break up anti-regime demonstration called by independent initiatives on Prague's Wenceslas Square to commemorate 71st anniversary of Czechoslovakia's foundation. Security forces detain more than 350 participants, of whom 229 are released the same day, while 149 remain in temporary detention cells. In total 1,172 are questioned and have their documents checked.

3. – 5. 11. 1989　In Wrocław, Poland, an international symposium on culture in Central Europe is held, at which – despite measures taken by the Czechoslovak communist authorities to prevent

its citizens from attending – around 4,000 Czechoslovak citizens are able to meet in person with leading figures from Czechoslovak independent culture and from the exile community abroad.

11. 11. 1989 Several hundred citizens gather at Zdeněk Nejedlý Square in Teplice wearing veils or gas masks and chanting 'We Want Clean Air', 'We Want Healthy Children' and 'Give Us Oxygen'. Although the security forces approved a plan of security measures, they are taken by surprise by the number of demonstrators and limit themselves to checking the documents of participants. However, the demonstrations in Teplice continue for a further three days, during which there are clashes between demonstrators and security units.

12. 11. 1989 Canonization in Rome of Agnes of Bohemia, daughter of Czech king Přemysl Ottokar I, who devoted her life to good works.

17. 11. 1989 A sanctioned gathering of students to commemorate 50th anniversary of the death of student Jan Opletal is held at Albertov in Prague. The same day, Czech Interior Minister František Kincl issues secret order authorizing the deployment of security force units and emergency security measures for the period 17th to 20th November. After the end of the official part of the event at the Slavín memorial tomb in Vyšehrad, a crowd of some 25,000 students forms a procession heading for the city centre. The number of participants constantly grows and the crowd chants demands calling for freedom and democracy. At Národní třída (National Boulevard) the procession is stopped by a cordon of state security units and in the evening state security forces intervene savagely against the remaining surrounded participants of the peaceful student demonstration. Members of the Public Security Force riot squad (VB SNB) and trainee public order units of the SNB, supported by armoured personnel carriers, brutally beat and disperse these demonstrators. The intervention causes an immediate wave of opposition among the informed public.

19. 11. 1989 Civic Forum (OF) is founded in the late evening at Prague's Činoherní klub theatre. It unites hitherto separate independent initiatives involving church representatives, artistic associations and other citizens aiming for a change of regime.

21. 11. 1989 In his declaration *To All People of Czechoslovakia* Cardinal František Tomášek supports the emerging democratic movement. On 27. 11. 1989 a general strike takes place between 12 a.m. and 2 p.m. over the whole of Czechoslovakia. Civic Forum and its Slovak counterpart Public Against Violence (VPN) assign to this strike the role of an informal referendum on the Communist Party's leading role in society. Slogans like 'An End to the Government of One Party' and 'Free Elections' dominate.

29. 11. 1989 The Czechoslovak Federal Assembly approves a change to the constitution removing the article on the leading role of the Communist Party and the article on Marxism-Leninism as the state ideology. A parliamentary commission to supervise the investigation into the events of 17th November 1989 is also established.

4. 12. 1989 At a meeting of Warsaw Pact member states representatives of Bulgaria, Hungary, East Germany, Poland, Romania and the Soviet Union in a joint declaration designate the military intervention in Czechoslovakia in August 1968 as mistaken, unjustified and illegal.

8. 12. 1989 First round of talks takes place in Prague involving representatives of Civic Forum, Slovak VPN, the Communist Party, the Union of Socialist Youth (SSM – official Communist youth organization), the Czechoslovak People's Party, the Czechoslovak Socialist Party, the Democratic Party and the Freedom Party. The Communist Party Central Committee sends letters to delegates of regional party conferences in which it announces that the Communist Party gives up its monopoly of power and ideology and rejects the Stalinist concept of socialism. The letter further states that a return to previous methods of implementing power is impossible, that the current Communist Party

leadership distances itself from the party's previous leadership, that it condemns the intervention of the Warsaw Pact armies in August 1968, and that from now on it will seek political influence only through political means in democratic competition.

10. 12. 1989 Gustáv Husák appoints a new federal government and then immediately abdicates as the country's president.

28. 12.1989 The Czechoslovak Federal Assembly elects Alexander Dubček as its chairman.

29. 12. 1989 At a ceremonial session at Prague Castle the Czechoslovak Federal Assembly unanimously elects Václav Havel Czechoslovak president.

The chronological overview was taken from the web presentation of the Institute for the Study of Totalitarian Regimes *Cesta k Listopadu* (The Path to November) (https://www.ustrcr.cz/uvod/cesta-k-listopadu-1989/).

SOURCES AND LITERATURE

The archive of the security services and daily reports of the Federal Interior Ministry (FMV) are available (in Czech) at: www.ustrcr.cz/cs/denni-situacni-zpravy-1989.

Information About Charter 77 (complete electronic version of samizdat newspapers), available at: www vons.cz/informace-o-charte-77.

Jiří Suk et al.: *Chronologie zániku komunistického režimu v Československu 1985–1990*, Praha 1999.

Oldřich Tůma: *Zítra zase tady! Protirežimní demonstrace v předlistopadové Praze jako politický a sociální fenomén*, Praha 1994.

LIST OF ILLUSTRATIONS

ABOUT THE AUTHORS

DANIEL KROUPA (* 1949)
Philosopher, politician, university teacher, journalist.

Philosophy graduate of Charles University, Charter 77 signatory, leader of underground seminars at private apartments.

In November 1989 member of Civic Forum's coordination centre. Co-founder of Civic Democratic Alliance (ODA) political party (party chairman 1998–2001). Deputy of Federal Assembly (1990–1992), parliamentary deputy (1996–1998), senator (1998–2004), deputy of European Parliament (2004), social service at Nový Knín Catholic charity (2004–2007).

Head of Department of Political Science and Philosophy at Jan Evangelista Purkyně University in Ústí nad Labem (2005–2017), where he still teaches today.

Author of several books and numerous academic articles. Regular commentator on political events on television and radio, in newspapers and magazines.

MONIKA MACDONAGH-PAJEROVÁ (* 1966)
Diplomat, university teacher, author.

Graduate of Faculty of Arts at Charles University (Philosophy, English, Scandinavian Studies 1984–1990). Spokesperson of striking university students (1989).

She worked for Foreign Ministry (from 1990) as cultural attaché at Czech Embassy in Paris, official at cultural committee of Council of Europe and ministry spokesperson.

Author and presenter of programmes about EU for Czech Radio and TV. Professor at Charles University and at Prague branch of Center for International Educational Exchange (where she teaches American university students in Prague).

Holder of French Order of Merit for her contribution to European cooperation.

JOLYON NAEGELE (* 1955)
Journalist, political analyst, native of New York.

Graduate of School of Advanced International Studies of Johns Hopkins University (Bologna – Washington, D. C.) – Internal Relations. He studied Czech language and literature for one year at the School of Slavonic & East European Studies, University of London.

Editor of Business Eastern Europe and monthly Doing Business in Eastern Europe (1980–1984). East and Central European correspondent for Voice of America, office director (Vienna 1984–1989, Bonn 1989–1990, Prague 1990–1994). His work covered the disintegration of communist power in the entire region, ethnic conflict in the Balkans and Caucuses, and the break-ups of the Soviet Union, Yugoslavia and Czechoslovakia.

Editor-in-chief and political analyst for countries of former Yugoslavia at Radio Free Europe/Freedom (Prague 1996–2003).

Political analyst at UN peacekeeping mission in Kosovo (UNMIK – Prishtina 2003–2017), deputy head of mission at Kosovo Central Electoral Commission and coordinator for dialogue between Prishtina and Belgrade (2003–2006), political director, head of political section at mission (2007–2017).

He currently lives in the Czech Republic, where he lectures, writes and researches the files of former State Security Service (StB).

JAN SOKOL (* 1936)

Philosopher, translator, university professor, author of several publications on philosophy and also books on computers.

Trained as a goldsmith, he completed school-leaving exam as an external student and studied mathematics at Charles University also externally. He worked as a computer programmer at the Research Institute of Mathematical Machines (Computing), where he was a department head. Since 1991 lecturer in philosophy, anthropology and religious studies at Charles University. As visiting professor he taught ethics and human rights at Harvard University in the 2008/2009 winter semester. First Dean of Charles University's Faculty of Humanities (2000–2007). His philosophy is influenced by phenomenology and personalism; his main interests are philosophical anthropology, the anthropology of institutions and ethics.

Signatory of Charter 77, he was active in political life after 1989. Education minister in 1998, presidential candidate in 2003 for coalition of parties. Awarded rank of Officer of French Legion of Honour in 2008, awarded Vision Foundation prize in 2017.

OLGA SOMMEROVÁ (* 1949)

Documentary film-maker, pedagogue.

Studied at Film and Television Faculty of Academy of Performing Arts in Prague (FAMU), where she taught (1991–2002) and was head of documentary department for eight years.

Her films examine social and human relations, significant personalities and phenomena of social and artistic life, feminism and recent Czech history, for instance political prisoners of the 1950s, the trial of Milada Horáková (executed by the communist regime), Charter 77, and the student revolts of the 1960s and 1980s. She was chairperson of the Film and Television Federation (FITES). She has made 127 films and received 40 prizes at Czech and international film festivals.